# GLASGOW
# SMELLS
# BETTER

# GLASGOW SMELLS BETTER

MICHAEL MEIGHAN

AMBERLEY

*For those friends from the '70s who have stayed constant.*

First published 2011

Amberley Publishing
Cirencester Road, Chalford,
Stroud, Gloucestershire, GL6 8PE

www.amberleybooks.com

Copyright © Michael Meighan 2011

The right of Michael Meighan to be identified as the Author
of this work has been asserted in accordance with the
Copyrights, Designs and Patents Act 1988.

British Library Cataloguing in Publication Data.
A catalogue record for this book is available from the British Library.

ISBN 978-1-4456-0266-0

Typeset in 10pt on 12pt Sabon.
Typesetting and Origination by Amberley Publishing.
Printed in the UK.

# Contents

# Acknowledgements

I would like to thank the following people and organisations for their help and assistance:

Jill for reading and censoring; Janis Mennie for Glasgow painting; *www. mennieprints.co.uk*; Janette McGinn for the photograph of Matt and permission to use 'The Effen Beekeeper'; USS Proteus and USS Partick Henry Holy Loch – Wikimedia Commons; Stylophone – Wikimedia Commons Dhscommtech at en.wikipedia Telephone GPO 746 – The University of Salford; Jimmy Logan's Metropole Theatre; Jessie Bremner for the image and to Matthew Lloyd at www.arthurlloyd.com; Chukka Boots – John White (Northampton) Ltd; Mr Happy – © THOIP and Mister Men Limited (a Chorion Company). All rights reserved. The Mr Men Show is a trade mark of THOIP (a Chorion Company). All rights reserved.

Adam McNaughtan for permission to use an extract from *They're pulling down the buildings next tae ours;* Stephen, Paul, Walter, Ann, Taam, Mikk, Veronica, Colette, Angela, Nancy, Jim and Sadie for their memories of Glasgow in the '70s.

I have made reasonable efforts to seek permission for illustrations and quotes and if I have infringed copyright inadvertently I apologise.

# Glasgow Smells Better

BBC News, 7 June 2000, (in response to an article that jobseekers should clean up their act when meeting employers):

> Michael Kelly, a former Lord Provost of Glasgow, said the city could launch a 'Glasgow Smells Better' drive to highlight the need for jobseekers to be presentable when meeting prospective employers. Mr Kelly borrowed from the city's famous 1980's 'Glasgow's Miles Better' campaign.

How could I resist the title? To many Glaswegians this motto would be very familiar indeed, and whenever I have mentioned it as the title of a forthcoming book, there is always a smile, because the 'Glasgow's Miles Better' slogan was instantly recognisable. It was a very successful campaign and Glaswegians always like a good pun.

The 'Glasgow's Miles Better' campaign was the brainchild of the advertising guru John Struthers and the theme was fully adopted by the Lord Provost, Michael Kelly, and the City of Glasgow's PR man, Harry Diamond.

Not only was the success of 'Mr Happy' one of the best Glasgow City slogans but it is recognised as one of the best ever PR jobs on a city and is credited with changing the fortunes of Glasgow.

The campaign was aimed at correcting the image that Glasgow was 'No Mean City' and in fact was both a welcoming and friendly place to live and work.

You can't overlook the bad side but I am glad to say we have moved on, and not in the least thanks to Mr Happy, provided by the late great Roger Hargreaves.

The campaign lasted from 1983 to 1989 and was successfully resurrected in 1994.

Of course this is a sequel to my previous book, *Glasgow Smells*, which was about growing up in the Glasgow of the 1950s and 1960s. This book starts a bit earlier than the Glasgow's Miles Better campaign, but the theme

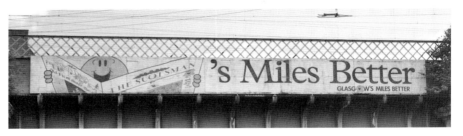

'Glasgow's miles better' campaign slogan.

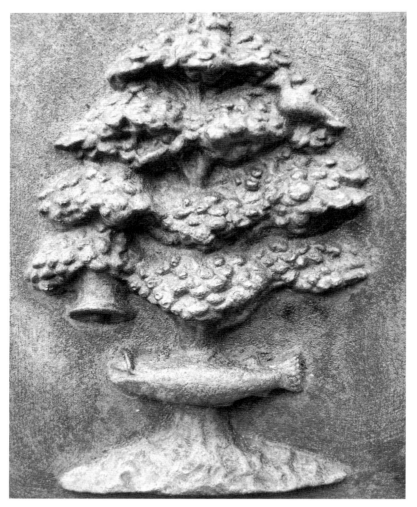

There's the tree that never grew,
There's the bird that never flew,
There's the fish that never swam,
There's the bell that never rang.

Michael Meighan

is essentially the same. It's about growing up in the Glasgow of the '70s and '80s with some reminders of what was happening then. But please be aware, it is not an autobiography, more a collection of essays.

I must confess that there are less smells to talk of now. The buses just don't smell the same as the 'caurs'. The cheese market, the fruit market and the fish market are gone from the centre of the city, as is the smell of the steam train from the Central Line. And the Underground doesn't smell the same at all!

The smell of Paterson's Camp Coffee factory has now been replaced with the smell of cappuccino and latte. The smell of cigarette smoke is all but gone and now we can smell the flowers in the Dear Green Place.

The dank smell of the river is almost gone and the sour smell of the close is on the way out. There have been massive changes in the city and mostly for the better. I have taken a bus ride through the city to see what changes there have been and to have a wee laugh at some of my memories of those days. And I have cheated a wee bit as I have started in the late '60s.

I am indebted to all of those who shared with me their thoughts and memories of Glasgow at that time and please don't think any the less of me because I now live in Edinburgh! In fact I'm a 'WIGLIE' – Works in Glasgow, Lives in Edinburgh.

Glasgow certainly smells better!

# The Bruce Plan

> They're pulling doon the buildings next to oors
> And they're sending us tae green fields, trees and flooers
> We do not want to go and we daily tell them so
> While they're pulling doon the buildings next tae oors...

Besides wee stories from the '70s and beyond, this book is about the modernising of Glasgow and the mistakes and the challenges along the way. There is no doubt that on an international stage, Glasgow is well on the way to being considered a modern European city, attractive to live in and attractive to visit.

Glasgow in the 1950s and 1960s was not an attractive place to live but plans were afoot to do something about it. While the Glasgow Garden Festival was credited as a real starting point in the mind of the Glaswegian, the plans were already underway. Maybe the Glaswegians didn't really have a full understanding of what was planned but when they woke up, the sparks began to fly.

The Bruce Report covered two reports put together by the City Engineer and Master of Works, Robert Bruce: the First Planning Report and the Clyde Valley Regional Plan. Had they been fully implemented then you would hardly have been able to recognise the city.

At the centre of the recommendations in the report were radical and alarming proposals to demolish large section of the city centre. And guess what? Among the things going were to be the Glasgow School of Art (shame on you sir!) and the City Chambers (naw!). Also going were the Central Station and the Glasgow Art Galleries (whit!).

As Glaswegians will know, the above didn't happen but a great deal of what he wanted did happen. Bruce wanted a new 'healthy and beautiful city'. How the destruction of the art school would have achieved this is anyone's guess.

There is absolutely no doubt that the slums had to go, irrespective of the human cost. We were part of it. My family was moved in 1964 from North

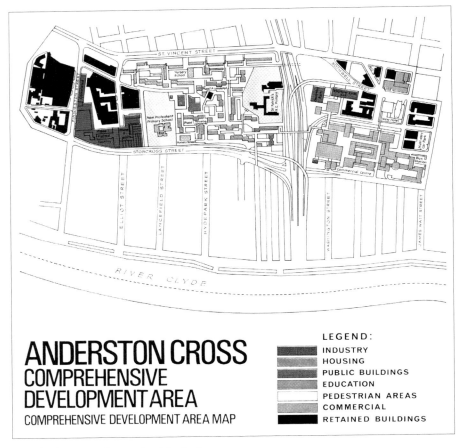

# ANDERSTON CROSS
## COMPREHENSIVE
## DEVELOPMENT AREA
COMPREHENSIVE DEVELOPMENT AREA MAP

LEGEND:
INDUSTRY
HOUSING
PUBLIC BUILDINGS
EDUCATION
PEDESTRIAN AREAS
COMMERCIAL
RETAINED BUILDINGS

Very little was to be retained in Anderston.

Street in Anderston to leafy Knightswood. My cousins from McIntyre Street went to a very early Easterhouse. Mrs Boyle from the next landing went to East Kilbride when it was one street, or looked it. We visited her once. Granny Durning went to Castlemilk from Brigton.

Yet we still maintained the identity and the friends for many years and some still do. People from Anderston living in other parts of the city regularly get together. You will now hear the refrain 'He's an Anderston Man' like a badge of honour. David McLaughlin once asked me if I had my USA car sticker.

'USA?' I ventured. 'Aye – Used to Stay in Anderston!'

Glasgow was well known for its sport, its education and an emphasis on culture – not just for the wealthy but for all its citizens. It was Scotland's biggest city until the '60s and '70s, and one of the most crowded cities in the world. Think about this when you see modern films of Hong Kong and Bombay. Unfortunately, along with overcrowding came poverty and ill health.

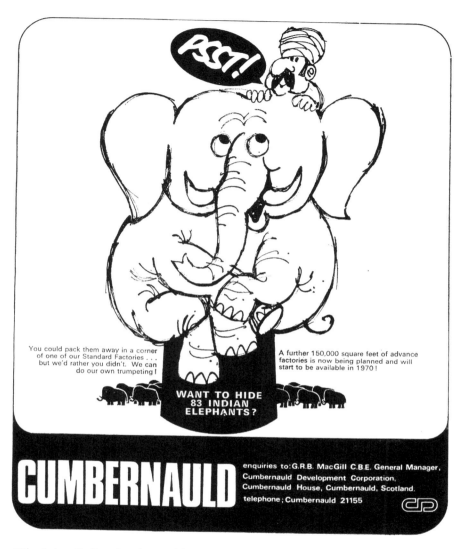

What's it called? – Cumbernauld.

It was time for change, but change was about to be forced on the city fathers through the New Towns Act. This was a Government initiative to tackle the issues of inner city overcrowding head-on by wholesale movement of populations to new towns of East Kilbride, Cumbernauld and Irvine in the west and Glenrothes and Livingston in the east. In order to facilitate this, no new build was to be allowed inside Glasgow City. So while there were existing 'schemes' such as Nitshill and Knightswood, there were to be no more massive housing estates within the city boundaries.

'We're on the road to nowhere.' The 'Ski Jumps', the original ramps to the M74 forty years on.

The Glasgow residents would be re-housed in new towns outside the city. All of this was seen by the Glasgow Corporation councillors as a move to undermine the power of what was one of the largest city councils in Great Britain. Glasgow Corporation knew that the New Towns Act was on the way and the Bruce Plan was the alternative vision of what should happen to the city.

Ultimately the Government won and the New Towns Act was enforced, at once creating East Kilbride, Cumbernauld and Irvine and ultimately cutting the Glasgow population in half.

One major thing that was done was the complete demolition of Glasgow's 'slum' housing and the re-housing of residents in new towns or in the new housing schemes on the outskirts of the city. Some said that these were to become the new slums!

Glaswegians will be familiar with the M8 and the Kingston Bridge as well as the M74. I would certainly take exception to the fact that we were moved from our slum tenement to make way for the Kingston Bridge. For our building was far from being a slum and was equal to many of the buildings still standing and since renovated in Anderston and Partick. We even had an inside toilet and a bath! However, oor hoose certainly wasn't big enough for a family with four boys and the move was our chance for a new start away from the smog of the inner city.

The new M8 – M74 link.

The M8 was built and we were moved. While the building of the motorway through Anderston, Cowcaddens, Kingston, Tradeston and Govan did mean the removal of many slum houses, it also meant the removal of many fine buildings, particularly at Charing Cross, including the whole east side of my own North Street and the famous Wooden Hut and The Office pubs. Charing Cross railway station was moved to a new location.

What is not realised is that the M8 through these areas and the M74 in the south and east was only part of what was to be an inner Ring Road; this road was to go through many of the 'leafy' parts of Glasgow. There was such an outcry that the rest of the Inner Ring Road Initiative was shelved. This included a motorway through Maryhill and north to Balloch!

It has taken forty years for the completion of the link from the M8 to the M74. While not the exact route suggested by Bruce, the link is now there.

When it came to railways, Bruce was obviously a 'Brutalist' with no sense of heritage. Glaswegians will know that in the '60s we lost St Enoch and Buchanan Street stations to cuts and the developers. Bruce wanted to get rid of all four stations, including Central and Queen Street stations and replace them with a Glasgow North and a Glasgow South Station. It just wouldn't have been the same. St Enoch and Buchanan Street stations did close but these were as a result of the Beeching cuts and not as a result of the Bruce Plan.

One major but cosmetic change was the redevelopment of the Underground. Now we have 'The Clockwork Orange'. The smells of the tunnel are still there, if not the leather, wood and electric smells of the

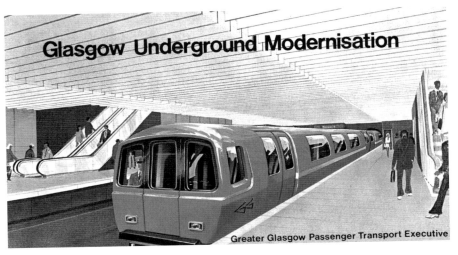

**Glasgow Underground Modernisation**

Greater Glasgow Passenger Transport Executive

'The Clockwork Orange'.

cars. The trains are now more modern-looking and, in the way of the Glaswegian, they developed the very apt nickname reflecting the look of the train as well as the film of that name starring Malcolm McDowell and Michael Bates.

I made a journey back to Glasgow with my son Chris, whom you will read about later. We visited the excellent Glasgow Transport Museum when it was in the Kelvin Hall and travelled back to town via the Underground at Kelvin Hall Station. I had not been in one of the renovated stations and I was very interested. The smell is different from what it used to be but the dampness is still there.

There was no one else on the platform but my son and myself. He, probably incited by me, decided to look through the emergency door at the end of the platform to see what could be seen. Just as we had satisfied ourselves that it was indeed very dark, a very loud voice seemed to come from everywhere, bounce off the tunnel walls and remonstrate with us:

'Just leave the feckin door alone pal.'

It was then that I spotted the TV camera.

'Feckin' is a great word, don't you think?

# The Bote Hoose

We have come full circle. I'm an Anderston Man and very recently I watched from one of the new hotels in Argyle Street as parts of the Anderston Centre were pulled down. I had first seen the tenements pulled down to make way for the ill-fated bus station and the network of walkways leading to offices and shops, which were never used. The idea didn't work and the huge centre gradually became a slum.

Basil Spence's Hutchesontown flats were among the first of the huge tower blocks to be pulled down and others are in the firing line. The Glasgow City Council houses now belong to one of the new housing organisations, the Glasgow Housing Association, and they have decided mostly to demolish. First in line are Sam Bunton and Co's 'Slabs'. Those concrete towers in Springburn are going to be demolished over the next few years. On the other hand there are plans to convert some of the flats into private towers. This would be quite an accomplishment in the Gorbals and would give a new slant to 'bote hooses'.

An official of Glasgow Museums has likened the flats to the Egyptian pyramids: 'Some of these flats are bigger than the Egyptian pyramids and in the next few years they will all disappear one by one.' Very strange. By the way, the French tightrope walker Didier Pasquette walked between two of the blocks in 1977. Amazing. One of the residents was heard to say, 'What a right Didier!'

The 'bote hoose', by the way, was very dear to us all. When Mrs Thatcher introduced the 'Right to Buy' scheme in 1980 it was pounced upon enthusiastically by a large number of people. These early pouncers were the ones who wanted to let you know that they had the 'bote hoose', as measures were immediately taken to paint the windows different colours from corporation green. Brickwork became red, set in white-painted cement. Palladian columns were to be seen. Canopies and conservatories sprang up and driveways were monoblocked. The most recent innovation has been, in Alderman Road: illuminated house numbers above the door. I swear it! At least they were not flashing. That's probably just for Christmas.

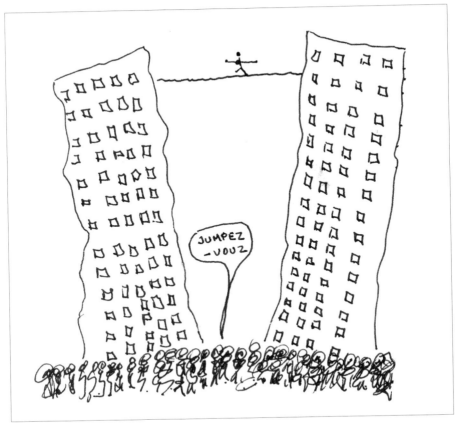

Didier fall or was he pisht?

Janis Mennie.

While we are on the subject, I suppose if you bought a flat in the Rid Road it would be pyramid selling?

As they were not allowed to build more houses, Glasgow City Council began to invest heavily in improving the housing stock. Many of the high-rise flats were restored and renovated and the concierge service was installed to improve security and customer service.

Many of the houses built in the '20s and '30s were renovated, acquiring new roofs, windows, kitchens, bathrooms and damp proofing. The tenants were still able to buy and now you can tell which ones plunged in early. You can see this in leafy Cardonald or Knightswood, where semi-detached villas predominate. The 'bote hoose' is now the one with half old harling and windows, and half nice clean white harling and brand new windows, doors and roofs. It's all damp-proofed and mainly has new central heating. And the renovated ones are still for sale to the sitting tenants.

# High Rise

Talking about the Concierge Service (s'il vouz plaît), I had the privilege over the period of about eight years of training the staff at the Glasgow Housing Department in handling violence and aggression. No – not how to be violent. Inevitably during this time I acquired a wealth of Glasgow stories.

We all know what a jobby is. Well, this one started off at the top landing of the stairs of one of the twenty-storey blocks of flats in Lincoln Avenue (The Lincoln). And if you can believe it, I used to deliver papers there and often the lifts were broken!

The Lincoln, by the way, is also the nearby pub, on the Great Western Road, which I happened to be passing very recently with my wife. 'That used to be a really rough place,' I said, just as a person was thrown out of the door to fall roughly on the pavement. Oh dear!

Anyway, the story told to me was about a time prior to the new concierge service and the new and improved cleaning and security. Apparently the jobby had been spotted and ignored as it made its way down the twenty storeys. No one was sure how it was happening, but one interested but sad resident had clocked this and kept a sort of a diary. The presumption was that tenants on one floor had simply given the increasingly tough and dried-up offering a kick and it would go sailing down the stairs to the next landing. It took several weeks but it eventually arrived at the bottom landing when somebody really had to do something about it. Apparently it was given protected status and became a Shite of Special Scientific Interest.

I am not sure what this illustrates except that Glaswegians can be very proud of their own wee patches but the immediate vicinity is of no concern. This gives rise to an extension to NIMBY (Not In My Back Yard), which is PIHBY – Pit It in His Back Yard. Of course there is also NIMBYE (No In Ma Back Yard Either). 'Wendy', of course refers to those who live in the West End.

Once, on visiting Queen Elizabeth Square in the Gorbals, I noticed that the newly appointed and decorated entrance hall was sporting some very

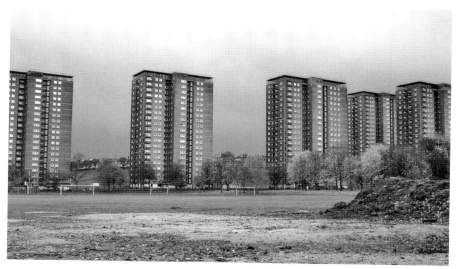

'The Lincoln'.

nice flowers. 'My goodness,' I said, 'the Council has really pushed the boat out this time.'

'Oh no,' said the Concierge, 'that was the tenants. There is now a queue to get back into the flats'. The Changed days showed me that with a bit of encouragement and support, those residents could look after their properties. One of the problems in the past has been the utter pointlessness of even trying. Well done Glasgow Housing Department.

Now in order to give my courses some immediacy I would sometimes make up stories. My approach to handling violence and aggression was to always start on the basis that some people had every right to be angry about their circumstances and the way that staff both understand and handle this makes all the difference. Anyway, there were twelve on the course and I told a story. I said 'It's a wet Wednesday afternoon on the fifteenth floor of a high-rise block of flats. Ashley is seventeen. She has a wee one in the cot and another on the way. Her partner is sitting in the living room watching TV and on his third can of Special. He has also been smoking dope. Now I know that's hypothetical'.

'No it isnae!' they all shouted'. Nuff said.

On the subject of the concierges, have you noticed the penchant (that slipped in) that Glaswegians have for calling things with French names. In a previous narrative I have mentioned this in relation to foyers and banquettes. But housing schemes? The Chateau Lait and Le Drumchapelle are very familiar to the Glaswegian. I have also heard a reference to Le Garngad! And there is always the story of the Glaswegian who saw the Channel: 'Merci,' he said.

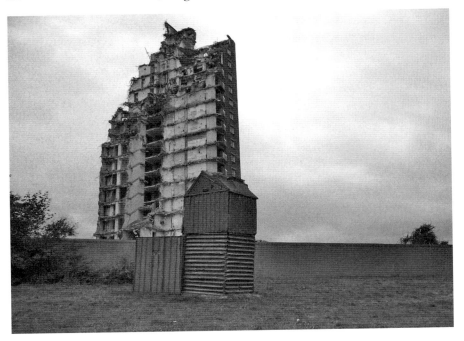

Still life with doocit – Plean Street.

French Quarter, Dumbarton Road.

You know that sometimes you think you have seen and heard everything until something comes along and just makes you gasp? Such was the story told to me and the rest of the class by one of the concierges one day.

The story involves two Housing Department staff who were called out on a blazing hot day to fix a drain below a woman's window. They turned up and sweated to lift the concrete and dig down to the leak. On taking a break the woman came out to them and offered them a can of beer each.

'We cannae missus. It's no allowed on duty.'

However, she persuaded them and gave them a cold can of beer each, which they took as much out of politeness as anything. This being done, she went inside, got on the phone and shopped them!

I tell you the story as told to us and I have to tell you that it was sufficiently un-Glaswegian in its horror as to embarrass and distress all that were there that day. I wish you could renovate people the way you can renovate hooses.

Now, where was I? Oh yes. I was telling you that, because of the clearances, we had moved out of Anderston, the quiet fishing village on the Clyde, (ref Billy Connolly) to the leafy glades of Knightswood, that garden enclave in the west of Glasgow with its romantic visions inspired by such unlikely but true places as Thane Drive, Ivanhoe Road and Cedric and Baldric avenues. Talking of Ivanhoe, there was the Ivanhoe Hotel in Buchanan Street (now the Buchanan Hotel) that, according to a 1970s advert, dates to before Sir Walter Scott. Work that one out. On the other hand there *was* another Ivanhoe. He was the first Russian farmer.

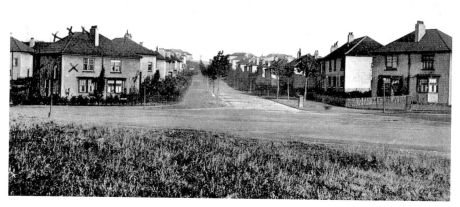

Knightswood.

Anyway, the house we moved into was indeed of a singularly English cottage appearance and we thought ourselves lucky in that it was a solid two-storey semi-detached built in the '20s, before the schemes. The interiors had not been redecorated since first occupied and therefore the décor was of that period, with much-varnished wood, picture rails and wooden windows. Still, a few gallons of magnolia from Woolies sorted that out pretty quickly.

You must remember that the mission in the '70s was to blot out any trace of what could be called architectural merit. The great craze was to cover all panelled doors with plywood sheets and paint them pastel colours, if not magnolia. And I have to confess that I too contributed to the feast of barbarism by painting my granny's kitchen chairs gloss white, adding nice red cushions. These were made from a dress of my auntie's which I thought was being discarded but my mother had it for taking up the hems. My only excuse was that you had to be there. And of course we have spent the past thirty years stripping gloss paint off the nicest mahogany (ma-huggani).

Of course, the move to Knightswood was not inevitable. While I wasn't aware of it then, my parents were holding out for a decent 'decanting'. While we rented the house in North Street, it was to be demolished to make way for the Kingston Bridge. The powers that be were anxious to get ahead and many people used that to their advantage to the extent that one family barricaded themselves alone into a tenement in Stobcross Street swearing that removals would be over their dead bodies. I did indeed hear of the wet cement of the Kingston Bridge being used for such internment purposes. Stop me if I am repeating myself; I may already have told you the story of the pleasant little Glasgow laddie who fell into the cement and came oot a wee hard man?

There was also the doubting Glaswegian who built a toilet out of cement blocks so that he would have something concrete to go on! And by the way, these jokes are all original. At least that's what I was promised.

Anyway, we were dragged to see flats at George's Cross, prefabs in Pollock, bungalows in Scotstoun and several others. It seemed that the patience of the powers that be was wearing thin when we were sent to see the house in Alderman Road. Of course it was magic. A house with a garden! We were over the moon!

The first few days were spent exploring the house and the garden in which was a strange structure that was explained to me by my father. This was an Anderson shelter, named after Sir John Anderson, who had responsibility for air raid precautions. Apparently it was designed and a prototype built all within three weeks in 1939. Apparently 2.3 million of these were distributed nationally.

It was made from six sheets of corrugated steel and was designed to accommodate six people along sleeping benches attached to the sidewalls.

Anderson shelter *c.* 1940.

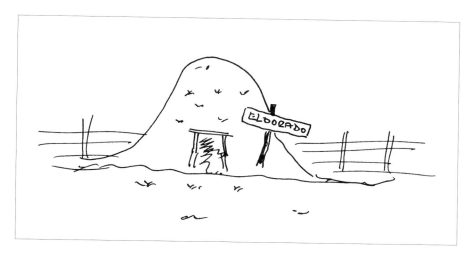

The idea was to cover these shelters in sandbags or soil. There were no signs that this had happened to ours, although the neighbours had a big bulge in the garden with steps going down into it. Of course, that might have been their wine cellar as it had a sign on it that said 'Eldorado'.

The estate (or scheme) was quite frankly amazing. While there were many slums in Glasgow, there had been moves to provide new housing, although this had been interrupted by war and depression. The Corporation had got moving again, particularly with developments like the famous Moss Heights, for which my uncle was the heating engineer. I believe that Moss Heights were to be the first ever high-rise flats in Europe, but they did not make the mistake of building these in isolated outskirts and providing no resources. They were built at Bellahouston, right next to the Park and a wide range of facilities. The only problem was they didn't have lifts!

And in order to show you the extent to which the corporation had been considering new ideas, I must tell you about Nitshill.

# Nitshill

I think that Nitshill was unique in Scotland. It had a centrally heated housing scheme that really was central. A boiler plant supplied hot water to all the houses in the 'Scheme'.

Long before the Bruce Plan was put forward, Nitshill was the most innovative of schemes, employing the best of Le Corbusier but avoiding the stupid walkways intended to separate people from traffic and which generally became gathering places for the nyaffs and neds of the Young Team.

Nitshill was a garden city and looked it. The buildings were no more than three storeys, were light and airy, and each had balconies, which I remember with pleasure. At Newfield Square we looked over a bowling green and tennis court. On the long, hot summer days we sat in deckchairs as on a steamer and listened to the plip-plop of tennis balls, claps from the older people on the bowling green, and general noises from the children in the roads round the square, which was very free from traffic at that time. And, incongruously, I remember regular visits from a rag-and-bone man, complete with horse and cart with car tyres! He would make his way round the square giving away inflated balloons in exchange for old clothes and jam jars.

While we are still in Nitshill, a word about my Uncle Pat who stayed in a roomy top-floor flat in Newfield Square along with Aunty Polly and my two cousins, Raymond and Gerald. Probably for my mother's health, I would be pushed off to Nitshill for the weekend, or prolonged periods, in the summer.

Now, as I have said, Nitshill was centrally heated from a boiler plant and my uncle was the plant engineer. This was a very important position and he, once or twice, would take me with him at a weekend to check that all was well with the three huge marine boilers. Now, these boilers were coke-fired, just like the ones that heated the swimming pool at Hydepark, but I do remember the difference. The boiler room was spotless and dust-free as far as I can remember. It was light and airy and there was a little glassed-in office for Uncle Pat.

Of course, he didn't have to go up to 'The Plant'. He only had to feel the heat in the radiators to know that the plant was working efficiently.

Now, I was used to him doing this regularly and you would get used to his commitment to ensuring that the thousands of people in the scheme were kept cosy. However, one night, he did feel the radiator and it was cold. He then went to other radiators in the flat to check if it was maybe just the one in the living room. But no, there was no heat. So, in his position, he had one of those big black Bakelite telephones with the little drawer underneath where you could keep telephone numbers. As far as I remember, my aunt and uncle were the only people that I knew who actually had a telephone, albeit that it was on a party line, which is shared with other people. If you picked up the phone and heard talking you had to get off till they had finished.

Anyway, he phoned the plant and nothing. There was no response.

'I'll better away up and see what the problem is,' he said.

'Can I come?' I said.

He looked at me and said, 'Come on then,' not anticipating that it would be anything other than a breakdown about which he should have been informed.

So we got on our coats and hurried up to the plant that was about two streets up the hill.

We walked into the building and past two of the big marine boilers that were stone cold. I could hear voices coming from the little cabin and there, sitting round Uncle Pat's desk, were the two stokers, rolling drunk with at least one bottle on the table in front of them.

He looked at them till they turned and finally took notice. It was like Burns: The moments whiled away wi' pleasure...

While his coat was coming off and his sleeves were getting rolled up to start shovelling coke into the boilers, he turned to me and said, 'Get away back to the house and tell your auntie about this and that I'll be some time. If the boys are there send them up.' I must say, I remember Uncle Pat being among the most placid of men, but I am glad I wasn't there to see what he thought of the boilermen that night.

There is a confusion about working class heroes and what working class actually is, or was. Uncle Pat was a plant manager, but also a lifelong trades union member and official who would take me to the May Day Rally. I would be on the boilermakers' float as it made its way through the town 'up Sauchie, doon Buchie and along Argyle' and over the bridge to Queens Park, where there would be the Labour Party May Day rally. At that time there didn't seem to be a distinction between manager and worker. You were all working class and in many cases, those who had bettered themselves through education to become managers and teachers were highly respected.

Working class meant working and usually working hard. It had nothing to do with needing handouts or sympathy. It had everything to do with the dignity of work and the need for equality and parity with others; rights to work and rights to education. As far as I can remember, Uncle Pat was the

only one I knew who was in a trades union. While everyone else around me, I suppose, made me a socialist, he made me a trades unionist.

For those who live in Nitshill now, my idyllic description may come as a surprise, but not half as much as the surprise that greeted me when I did a return to that spot this year. Having got a train to Nitshill I was immediately lost and referred myself to an elderly gent to enquire into the whereabouts of Newfield Square. It was my intention to take a few photographs to illustrate this book.

Well, first of all, this gentleman's attention was divided between myself and the police, who were sorting out some kind of a fracas at the wine merchant's opposite. He eventually pointed me on my way with a face which said to me, 'Whit's the big man going there fur?' Well, he might well have said that as when I got there I was both shocked and saddened. There was nothing there.

I recognised the shops, one of which had reputedly been the very first supermarket in Great Britain operated by the Co-op. This was where my Auntie Polly would take me to place her message bag in a wooden pigeonhole and take a wire basket, the process being reversed at the end of the shopping. Gone was the Co-op and very miserable the area looked now.

The biggest shock was the absence of Newfield Square. The only sign of it was the path that separated bowling green from tennis court. Gone was the thunk of bowl on bowl and the twang of ball on racket. Gone were the young people on bikes and their elders in their well-kept gardens tending their roses. Gone were the buildings and gone were the roads, blocked off with concrete barriers. Gone was the central heating plant. Even the church was boarded up.

Maybe my memories were wrong. Maybe as a young man I had a utopian vision of how life should be lived and maybe Nitshill supplied that vision. I don't know, but I didn't take any photos. Incidentally I recently read that someone thought that Glasgow's new architecture was based on le Courvoisier. Sounds about right.

Prefabs in Pollock. Down in the jungle, living in a tent, better than a prefab – nae rent!

# The Babyboomers
# in the 1970s

It was in the 1970s that the baby boomers came of age. We were born and forgotten about as others got over the war. But we came out of school and made the '70s our own. Life had been held up for a generation before we were born, but we made up for it without apology and helped it along without a care in the world.

We started the '70s with nothing but dreams. We ended the '70s with small children, small houses, small cars and large mortgages. In between there was change, tragedy and drama, but we made the best of it man. We were so cool.

Change was the slow passing of the last lamplighter from the close and street. It was the ending of checking the air raid siren on a Wednesday. Change was the introduction of the Trimphone. Change was the last of the half crown and the sixpence, the last of the ten-bob notes.

Change at work was the introduction of the Health and Safety at Work Act and the Equal Opportunities and Race Relations Acts. We began to study with the Open University. We were sent home when the three-day week set in and we used the other two days to look for candles.

North Sea oil came ashore in 1975 but we forgot we had health and safety laws. I worked there for a while and it was scary. We ended a bad decade for deaths with the *Alexander L. Kielland* platform capsize killing 123 in 1980. *Piper Alpha* killed 169 in 1988. These were only the biggest. It's got safer, they say. Scary also was the train to Glasgow as the roustabouts celebrated the end of 'two on' and looked forward to 'two aff'.

The 1970s was moving into a student flat in Hill Street, where we painted the black cast-iron range white. We left dishes in the sink, drank bad Spanish wine and ate French bread stuffed with beans. We listened to Leonard Cohen, sang the blues and thought ourselves elected.

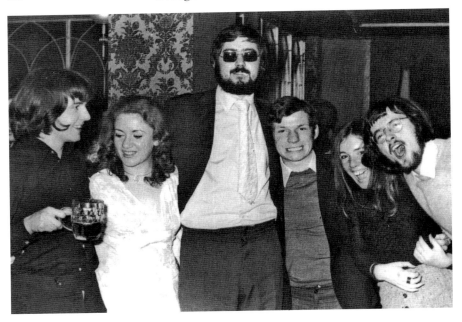

The Babyboomers in the 1970s.

The '70s was getting roaring in the Stakis Bier Keller, having to drink up at cowboy time (ten to ten) then throwing up over the Kelvinbridge. Apollo 14 landed on the moon. Green's Playhouse became the Apollo. The Lunar 7 opened and closed. We experienced the tragedy of the Ibrox disaster that changed Scottish football forever. We saw Glasgow change and improve beyond all recognition. We experienced the first possibilities at Mayfest, which stuttered and fell but is fondly remembered. The Garden Festival properly started the rejuvenation, and now we have Celtic Connections at our wonderful Glasgow Concert Hall, as well as the brilliantly successful West End Festival and the Merchant City Festival. Don't forget the World Pipe Band Championships and Glasgay. We have emerged into a new, modern, vibrant cultural city with the opening of the new Transport Museum to look forward to, as well as the Commonwealth Games in 2014.

We went to see John Mayall and Colosseum. Donovan released *Catch the Wind* in 1971 and competed with Dylan and Simon and Garfunkel for a while. Around the same time, Janis Joplin, Mama Cass and Jimmy Hendrix ate their last sandwiches. Still, throughout the decade, Scotland had the Bay City Rollers for consolation. I had Carly Simon. Still do. That's the way I've always heard it should be.

We watched, and still regularly watch, Alistair MacLean's *When Eight Bells Toll*. We went to see and wonder at a new cinema with Jack Nicholson

Glasgow cosmopolitans in the Merchant City.

in *One Flew Over the Cuckoo's Nest*. *The Wicker Man* came out and started a cult and Edward Woodward's career. I loved him and Russell Hunter in *Callan*. We ended the decade with a new cinema, and the 'Force' was with us for a while. Harrison Ford became an archaeologist and saved the world.

We got used to Edwin Morgan and Edwin Muir. I tolerated Morgan's affected 'concrete poetry' but loved him for the rest as the cup capsized along the Formica.

Tom Leonard's 'Miracle of the Burd and the Fishes' introduced me to how Glaswegian was actually written: 'thirz a loat merr fish in thi sea'. See me, see mince.

We didn't really see the creation of the new model cities. We never really appreciated Cumbernauld. We didn't notice that our past was being removed. We didn't know that the plastic phone and the polyethylene mug would be our downfall. We didn't see the last ship going down the Clyde or the last car out of Bathgate. Maybe The Proclaimers did.

I suppose we finally grew up. The baby boomers are sixty now, or thereabouts. We didn't know we had had it so good. Pensions and jobs for life if we wanted. We went on holiday to Spain and drank real Spanish wine. We buggered the environment and nobody told us. Sorry about that, pal. Still, as long as ye've got yir health.

Once upon a time there was a tavern...

Anyway, we almost made it, didn't we girl? Some of us didn't but are fondly remembered. So here's to the boomers, those of us who have made it so far.

'Wha's like us?'

'Naebody, and they're aw deid.'

# Culture

If anything has remained constant in the recent history of Glasgow it would be its excellent approach to culture and art. I moved away from Glasgow when I was about twenty-five to live in a wide variety of places throughout Great Britain. I don't suppose I was particularly aware of the lack of galleries or museums in other places, but this came home to me quite strongly with our move to the Highlands and Islands thirty years ago. I would not dream of criticising the lack of expenditure on, or thoughts given to, the visual arts in the North, but generally speaking you would have to go to the central belt to see any kind of exhibition or concert.

The investment in culture of the City of Glasgow has been impressive and was rewarded by Glasgow becoming the European City of Culture in 1990. The Glasgow Art Gallery in Kelvingrove has recently been renovated and tastefully extended. It is truly wonderful and deserves its position as one of Europe's most visited attractions, much of this by Glaswegians. While the Kelvingrove Art Gallery and Museum was opened in 1901, in my youth and infancy it was a bit dull and a bit intimidating to a wee boy like me, but it was on my patch and therefore fair game for a visit. However I do remember at the tender age of twelve or thirteen being taken by the scruff of the neck by a blue-coated attendant and placed in the confines of an office till the police were called. And all for going round and round the swinging doors. Who could resist? I was then ejected when it was felt that I had suffered enough. They obviously lied when they said the police had been called. I have to tell you that my greatest fear was of the appearance of the policeman whose shins I had kicked in a previous encounter (See my previous book *Glasgow Smells*).

Anyway, the better changes to the gallery started in 1952 with the exceedingly brave decision of Tom Honeyman to purchase Salvador Dalí's painting 'Christ of St John of the Cross' for the enormous sum of £8,200. This was to prove controversial because of its religious connotations and in 1961 it was attacked and damaged by a maniac. It was repaired and takes pride of place in a gallery filled with delights of all kinds.

Banned stand, Kelvingrove.

I have to tell you a wee story here about the Glasgow Girls. You may know that 'the Glasgow Boys' is the collective name for the group of Glasgow 'Colourists' including Joseph Crawhall, James Guthrie and Edward Walton.

Less well known is the group called 'the Glasgow Girls' of around the same time. They were a group of Glasgow women artists and included Frances Macdonald, Margaret MacDonald and Jessie M. King. Well, in 1990 Glasgow Art Gallery presented an exhibition, 'Glasgow Girls – Women in Art and Design 1880–1920'. The exhibition was truly wonderful and brought together the widest range of art, embroidery and silverware.

Some time after having attended the exhibition I was asked what I wanted for my Christmas. I had no hesitation. *The Glasgow Girls,* I said, referring to the superbly illustrated book that accompanied the exhibition and which was edited by Jude Burkhauser.

Christmas came and presents were duly opened, including mine from my Dear One. I was a bit mystified, as it appeared on opening to be a small paperback of 'Penguin' dimensions. I could sense wife, son and daughters looking at me quizzically as I looked at the title with a frown. It was indeed *The Glasgow Girls*, but about a fictional Glasgow family in Victorian times as written by Frances Paige. Nice enough in its way, but not my heart's desire. 'Bit of a cock-up on the Christmas communications front,' I said as I explained the problem.

'That's a bit of a relief to us all then' said my wife who had wondered about my choice of Christmas present – nuff said. I now have the book and it is still lovely. Incidentally, Tom Honeyman was instrumental in attracting

The Glasgow Art Gallery and Museum.

to the city, the bequest by Sir William Burrell. The said sir made some very strict rules concerning where his great collection was to be shown and it was many years before Glasgow got round to building the excellent Burrell Gallery in Pollock Park, itself a great venue for exhibitions. I saw the Van Gogh exhibition here as well as just visiting what is claimed to be one of Scotland's best buildings. I agree, by the way. Over the intervening years, the Glasgow Art Gallery did show a lot of the Burrell Collection and I had the privilege of seeing the fantastic exhibition 'Stained Glass from the Burrell Collection'.

It may also be of interest to you to know that Tom Honeyman was also involved in setting up the Scottish Tourist Board and along with John Brodie he founded the Citizens' Theatre – but more of that later.

The gallery, too, has improved. While there is enough to interest those keen on animal and fossil life, there is now a permanent exhibition devoted to The Arts and Crafts Movement in Scotland, The Mackintosh Gallery.

The Kelvingrove Art Gallery was just the best. If that makes me sound like an artistic wee fart, I wasn't. The art galleries were a brilliant place to go and see. There was a ship's paddle wheel and other machines that went round when you pushed a button. There was a rock display that lit up with ultra-violet light, the quartz and crystals gleaming in myriad colours. But by far the best were the ship models that you could look at for hours,

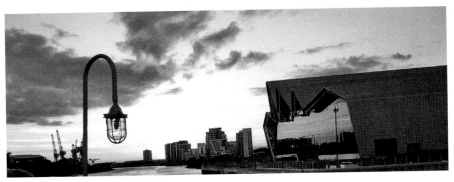

The new transport museum on the *Clyde*.

they were so detailed. Many of them came from the shipyard offices but here they were crammed together in the main concourse of the gallery.

Many years ago, Glasgow Corporation Transport was the first council to invest in the new and revolutionary Leyland Atlantean bus and it was used regularly on the 62 route from Anderston Cross to somewhere. We got off at Glasgow Cross to change.

One of the buses that I travelled on now has a place in the Glasgow Vintage Vehicle Trust in the old Bridgeton Garage in Fordneuk Street and it fair makes you feel your age, more even than the tram cars in the Transport Museum. My thanks to Lyn McIntyre and Ian Short of the trust, who corrected my poor memories and who are founts of information about vintage transport and particularly buses. You really should go and see it. Look out for the open days.

Of course we mustn't forget the Mclellan Galleries that, before they burned down, hosted many an exhibition and show, particularly after the original St Andrew's Halls burned down. Come to think of it, they used to burn down as regularly as Highland Hotels. However, the Mclellan Galleries rose as a phoenix from the ashes to host the magnificent Chic Rennie Mackintosh exhibition in 1990. I was there, by the way, so I can be as familiar as I like, particularly as he came from Parson Street, where I also went to school. I went to the Martyr's School, also in Parson Street, and this was designed by him when he worked for Honeyman & Keppie. Keppie Architects survives today.

On to the People's Palace, the sadly under-visited museum with its beautiful glasshouses. It now has a restaurant and must be one of the most delightful venues in Glasgow. I would go there as a child with my dad and stuffy it was. When I visited with my children they had things like Billy Connolly's Banana Feet and a model of a medieval Glasgow Street complete with plastic poo coming down a shoot as in 'gardey loo', which I believe means 'Station with the toilets'. Glaswegians are great at the

Martyr's School Parson Street.

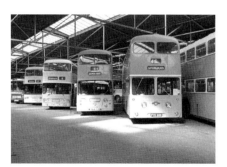

Glasgow Corporation Atlanteans.

French by the way. And while we are talking of art I believe that Toulouse-Lautrec was so called because of his multiple toilets. Or maybe he was so called because it was winter?

One of the most recent successes for the city has been the renovation of the famous Royal Doulton Fountain that has now been placed in a wonderfully landscaped area in front of the People's Palace. The Doulton Fountain is the largest terracotta fountain in the world. I remember it from when I was very young and used to go rowing on the Clyde above the weir. For years it was surrounded by scaffolding and held together

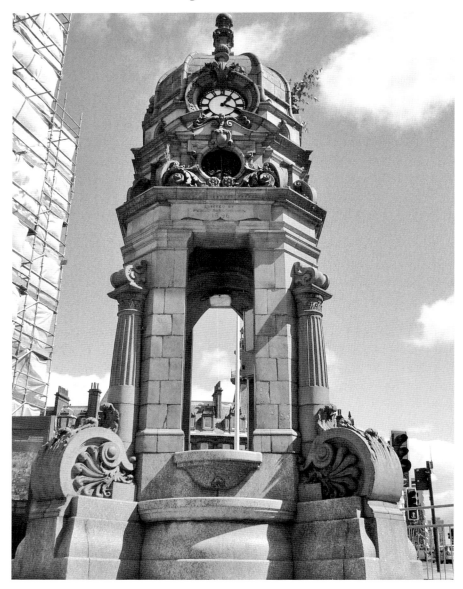

Cameron Memorial Fountain.

with wire. The fountain is a fine example of how art and architecture can be the centrepiece of regeneration such as that at Glasgow Green and in the East End. There is a long way to go, but the fountain and the People's Palace are a credit to the city. By the way, the leaning fountain of Charing Cross is also a product of the Doulton Company. It's about time they got it going again.

When I was a wean, my father would take us for walks, one of which was the one through the pedestrian tunnel at Finnieston and then along the south of the river, returning over the Jamaica Bridge along the Broomielaw. The best part of the walk was under the big iron-ore cranes, the galvanising works and the docks. When I went back there in 1988 it was the first time for many years and it was to see the magnificent Glasgow Garden Festival. The festival was set in what were the old Princes Docks and it was credited as the start of the real regeneration of Glasgow. With over 3 million visitors, this started Glasgow off as a real tourist destination and gave Glaswegians a real pride in their city and what it could achieve.

And it was 'pure-dead-brilliant'. Gone were the smells of the dock; even the sewery smell of the river seemed overpowered by the smell of flowers and greenery. But once again you could recall the smell of the tram because there they were: two 'caurs' going back and forward along the riverfront. You could wander through a wide range of fabulous gardens representing communities and groups. You could eat in a café in the South Rotunda

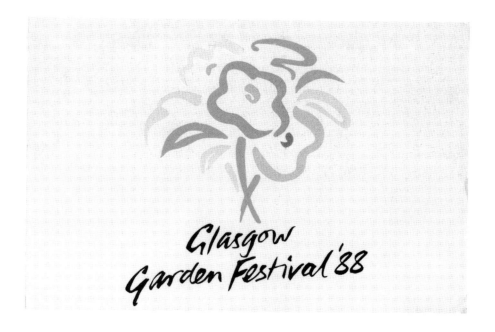

that used to be the way into the old Clyde Tunnel. There were concerts on the old Renfrew Ferry, as at that point it had been moved to Jamaica Bridge. You could, if you were mad, take a ride on the huge Coca-Cola roller coaster or go up to the top of the 140-foot Clydesdale Bank Tower.

It took a long time after the end of the festival for the area to be redeveloped but I can tell you that you can now cross the Bells Bridge from the Scottish Exhibition and Conference Centre to see the Glasgow Science Centre and go up the Millennium Tower that replaced the Clydesdale Bank Tower, which was lost to Wales for some reason.

# The Roar of the Greasepaint, the Smell of the Crowd

Aye, that was Glasgow in music hall days, but I wasn't there. I did go to pantomimes in the King's Theatre, the Alhambra and the Pavilion. The Glaswegian has always loved entertainment in its widest sense and has embraced pantomime and variety and has looked for this even on holiday, therefore ensuring the success of the Air Gaiety and the Rothesay Pavilion.

You may remember Hughie Green's 'Oppornockity Tunes' (as it was called in Glasgow). Well, some of the auditions for this were being held in Jimmy Logan's Metropole Theatre, then owned by the Logan family. The auditions were being conducted by Jimmy Logan's father, the famous Jack Short, himself a stage impresario. Jack was the man with the virtual big hook who would say 'Aye don't call us, we'll call you.' (but do it in a Chic Murray accent.)

It so happened that our folk group decided somehow to go for an audition and I can't remember why it was decided that everyone would wear a shiny blue suit with braid. By that time I had been relegated to 'manager' and was not at all unhappy to sit it out backstage. I'm going to pass over very quickly what happened on stage except that the hook came out quite quickly.

What I remember most about the whole strange affair wasn't so much the folk group in baby blue but the guy with the full Highland regalia that we got talking to in the dressing rooms. Nice enough guy, but such were ten-a-penny in those days of the White Heather Club. What was surprising was the fact that he volunteered that his chosen song for audition was going to be Blake's 'Jerusalem'! Of course this was before it, adapted by Vangelis, featured in *Chariots of Fire*, the film about the Scots Olympian Eric Liddell and fellow athlete Harold Abrahams. This was partly filmed in St Andrews and was released in 1981 to great critical acclaim.

All stirring stuff, but I have to tell you that Jimmy Logan's Metropole at St George's Cross was far removed from England's green and pleasant lands.

Jimmy Logan's Metropole Theatre.

We never got on to *Opportunity Knocks*. The world lost out, I feel. I could have had a career there!

While we are on the subject, I suppose you can call Jimmy Logan one of my heroes. Being brought up in Glasgow where Jimmy and his family were an institution just like the White Heather Club, I saw him in pantomime and variety shows at the Glasgow Alhambra. But unlike the White Heather Club, Jimmy Logan represented the true Glasgow and took Glasgow humour far and wide. For me, while I liked and respected him in pantomime, I thought that one of his best ever performances was as a boss in Bill Bryden's *The Ship*, which involved the creation of a sixty-seven foot wide model of a ship inside Harland & Wolff's former engine shed in Govan during the Glasgow year of Culture in 1990. This accommodated an audience of up to 1,200 and ended each night with the launching of the ship.

His journey to Eden Court in the dreadful winter of 1983 shows his showmanship and professionalism. It was a bleak winter night and snow had already been falling as we made our way from Dingwall with our small children to see the pantomime at Eden Court. During the show Jimmy was required to use an electric wheelchair with headlights (you had

to be there). During the show the house lights failed. This was a common occurrence in the Highlands due to the fact that the weight of snow on the power lines sometimes brought them down.

Jimmy was absolutely brilliant in the way he stopped any panic and kept us laughing with his illuminated wheelchair. It was clear after a while that the lights were not going to come on again, so he skilfully oversaw the evacuation of the theatre using only the emergency lighting and his headlights. A Super Trooper. He was also famous for the phrases 'Sausages are the boys' and 'Lovely biscuits'.

Back to Drama. While Glasgow was never short of theatres for variety or for opera, we only had one dedicated theatre for serious drama. This was the Citizens' Theatre.

1974 was a great year for Theatre. The Citizen gave us *The Cheviot, The Stag and the Black, Black Oil* by 7:84. There was also Bill Bryden's *Benny*, the story of the famous Glasgow flyweight boxer Benny Lynch. It was groundbreaking in its use of audio narrative.

That same year I was privileged to see Roddy McMillan in *The Bevellers*, his own play. Apparently Roddy practised for this at the glass company just up Argyle Street at Finnieston. In the play was also the young Paul Young, before moving on to greater things then taking up fishing (Hooked on Scotland). John Grieve, Jackie Farrell and Andrew Byatt were also in the play.

You will probably remember Roddy from *The Maggie*, *The Vital Spark* and *A View from Magnus Pike* in which he played a Glasgow private

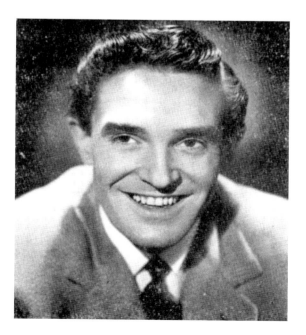

'Lovely biscuits.'

A young Paul Young.

detective. Roddy also contributed to Glasgow folk singing, penning 'The Govan Billiard Hall Song' as sung by Robin Hall and Jimmie McGregor. Some man! He died in 1979.

A little-known fact, and my thanks to Walter Soutar for this, is that both Roddy and Paul were in a 1972 Michael Winner film with Charles Bronson, *Chato's Land*, in which Chato (Bronson) is chased by a posse after killing a US Marshal in self-defence.

It was also a good year for cinema. As Mr Cosmo closed his doors, it was to re-open as the Glasgow Film Theatre. There I saw *Henry V* Parts 1-10, 'Films of Artistic Merit and spurious cult films'. Big Kevin and I went to see one; the 1971 film *The Mysteries of the Organism*. The main elements juxtaposed throughout the film explained by Wikipedia are:

Milena is a metaphor for the Yugoslavian working class's struggle for liberation against the totalising influence of the communist state. Milena is killed when her sexual encounter with Vladimir Illych (a reference to Lenin and the representative of communism) goes awry. He, unable to fully experience his orgasmic urge, beheads her with his skate which is the film's metaphor for revolutionary theory. Makavejev dooms self-determination of the Yugoslav people, and the struggle of people worldwide for true freedom, to the fate of being totalised by state communism, and the quest for sexual freedom.

I'm afraid the Organism still remains a mystery to me after all these years. I think I prefer Shakespeare.

Glasgow Film Theatre.

Before I leave this chapter I have to let you know before anyone else does that I contributed my own small effort to theatre on behalf of the Langside College Drama Club, for which I played 'a tramp' in the play *Fine Weather for Repentance*. My immortal line was: 'Armageddon?' Armageddon oot o' here!

No? I'll get ma coat.

# The Folk Singers

*Well, out of the east, there came a wee hard man, oh, oh, oh, aw the way from Brigton...*

This is going to be very embarrassing but let's start by getting the facts right. I never ever went to Rothesay, o and certainly not with a dirum-a-doo-a-dum-a-day! I never sailed on the sloop *John B* or the *Irish Rover* and I certainly never left Liverpool for anywhere.

On the other hand, I did make a complete arse of myself on stage, but as that didn't in the least matter I could have had a career as a folk singer if I hadn't grown out of it or lost my Aran sweater. Actually it was got rid of through the embarrassment caused to a whole generation of earnest folkies by Billy Connolly, who described those vocal interpreters of our Celtic heritage as civil servants putting on their Aran sweaters and becoming weekend folk singers. How true. Bastard!

I could have got over it in time had I not been caught on camera with said Aran sweater and period 'tash. To be fair, I wasn't the only one. Here we are (over leaf). Two Fair Isles, two Arans and Wyber with a cardie. How relaxed we were on stage before one of our biggest crowds, live at the Couper Institute in Cathcart. I think at that point we were called the Àlainn Folk. In Gaelic this means 'beautiful people'. Make up your own minds. Of course, a photograph is very forgiving. Neither does it tell you how out of tune we were or that we were probably singing, 'Old Stewball was a racehorse, I wish he was mine. He never drank water he only drank wine.' Very Glasgow.

Oh, and by the way, all you smartarse editors and readers. The Aran sweater is spelled correctly and exactly as I have it here. The name is derived from the Aran Islands off the west coast of Ireland. As far as I remember they were first sported and made famous by The Clancy Brothers and Tommy Makem.

I think I am pleased to have been involved in a little way with the folk revival of the 1960s, which was as much about anti-Polaris protest and

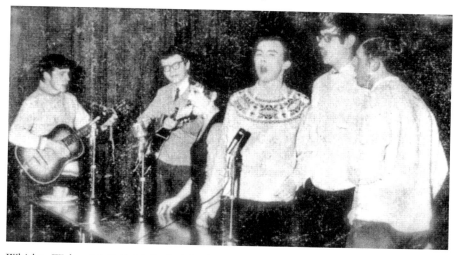

Whitley, Wyber, McFall, McBeth, Meighan and Heron live at the Couper Institute.

about CND as it was about singing. I even had the duffle coat with a CND badge, the chrome silver and black metal one. No the cheap plastic one!

If we didn't sing on the same stage as the folk singers, we went to see them. If not in pubs, then in the Glasgow Folk Club, which used to be in Montrose Street.

Among these was Matt McGinn, who had a similar background to, and who I think knew, my father. Both of them came from the East End and went on to become secondary school teachers as a second career.

Matt's output was prolific. In looking back at his songs and poems I was reminded that had he written 'The Ballad of John MacLean' and 'If it wisnae for the Union', and 'Three Nights and a Sunday (Double Time)' all of which endeared him to the Glasgow working classes. Most Glaswegians will also remember 'The Wee Red yo-yo' with great fondness. If you ignore the support of belting in the classroom as being a product of the time, 'Rap Tap Tap (Upon Your Fingers)' is a great wee song. And one of my favourites for humour is 'The Big Effen Bee':

The Big Effen Bee

He kept bees in the old town of Effen
An Effen beekeeper was he
And one day this Effen beekeeper
Was stung by a big Effen bee

Now this big Effen beekeeper's wee Effen wife
For the big Effen polis she ran

Matt McGinn
1928–77.

For there's nobody can sort out a big Effen bee
Like a big Effen polisman can

The big Effen polisman, he did his nut
And he ran down the main Effen street
In his hand was a big Effen baton
He had big Effen boots on his feet

The polis got hold of this big Effen bee
And he twisted the Effen bee's wings
But this big Effen bee got his own back
For this big Effen bee had two stings

Now they're both in the Effen museum
Where the Effen folk often come see
The remains of the big Effen polis
Stung to death by the big Effen bee

That's the end of that wee Effen story
'Tis an innocent wee Effen tale
But if you ever tell it in Effen
You'll end up in the old Effen jail

He died on 6 January 1977 at forty-eight. Some of his ashes were scattered
on the grave of the great John MacLean in Eastwood Cemetery.

# Back to the Band

I can't remember exactly how it started except we had one or two musical chaps in our school chums club, the 'MOB'. We started an underground folk movement, that is to say we first sang in the boiler room of our school, the Mungo in Parson Street. I swear that the boiler room still had the cobbles from when it had been a stable. The good jannie turned a blind eye and deaf ear to us as we wailed below among the stoor and smell of coke. No, not that kind of coke.

I am afraid that I was fairly pathetic with musical instruments and a fairly bad singer. That's why I eventually became the 'front man' and had to learn a repertoire of bad jokes to which I have sadly become addicted.

For example, did you hear about the man who ran over himself? No? Well, he stopped his car at the side of the road and asked a wee boy to run over to the shop and get him a newspaper. The wee boy said, 'Naw,' so he ran over himself.

Sad isn't it? And particularly so since the reason he couldn't go over in the first place is that he had been a chimney sweep but had got lumbago!

Actually I think that they now call chimney sweeps 'soot removal consultants'. And of course, plumbers are now 'cistern analysts'.

See? I can't help it.

Anyway, back to the band. McBeth invested in a Rolf Harris Stylophone that I plugged into my big Sanyo tape recorder to give us 40 watts of unexpurgated shite. He also, by the way, got a double bass that wasn't the easiest of beasts to cart around. This and the growing number of hingers-on meant that we had to invest in a third-or fourth-hand Bedford minibus that we named 'the pig'. It was quite handy in a way, as when the exhaust fell off we usually were able to dismantle guitars to get strings to hold it up.

I suppose that we reached the pinnacle of our careers in a four month 'season' in Duncan's back lounge at The Fountain in Coatbrig. But it was only the very best and the very courageous folk singers that carried on to

The Rolf Harris Stylophone. (Wikimedia Commons)

become household names. We faded into oblivion. (That would be a good name for a Glasgow pub.)

Meanwhile our contemporaries went on to do well. There was the Corrie Folk Four. Yes – there were originally four and they appeared at our school folk club, as did Bernadette, who gave us a fine rendition of 'The Forty Shades of Green'. There were the Humblebums with Billy Connolly and Gerry Rafferty, who went on to carve successful international careers.

Also more successfully commercial than us were Robin Hall and Jimmy MacGregor who were to appear nationally on *The Tonight Programme*. Remember Cliff Mitchelmore and Fyfe Robertson?

There was the String Driven Thing, Hamish Imlach and Archie Fisher, the latter two having survived well. Out of the blue I recently heard that the String Driven Thing were still on the go and after a search on the Internet found that to be the case. Given that I first saw them in a very cramped Griffin in Elderslie Street in about 1972, albeit with some changes to the line-up, that is some going. Chris Adams was the original lead vocalist with The Thing and has produced *Moments of Truth*, their first album for thirty years.

If I mention Christian to you, it will all come flooding back. Otherwise known as Chris McClure with The Section, he was very popular and they are still going strong. I am sure I had one of his 45s when I was younger. Born in Ibrox, he has been entertaining all over the world. What better accolade could there be than having a tribute show, as was presented at the

Chris McClure on the Dock of a Bay.

Pavilion in April 2002? He was very happy for this early picture (Previous page) to appear.

If you discount listening to Irish songs on my father's Dansette or pretending to like the music introduced to you by pretentious friends, my earliest memories of music was that heard on Radio Luxembourg in between the Tiffin adverts.

Neither can I pretend that I was a music lover in those days. But something strange happened when we got pirate radio. I think that the first pirate radio station was Radio Caroline in 1964 followed by Radio Scotland in 1965:

Radio Scotland
Playing just for you
So beat the ban
And join the clan
On good old 242.

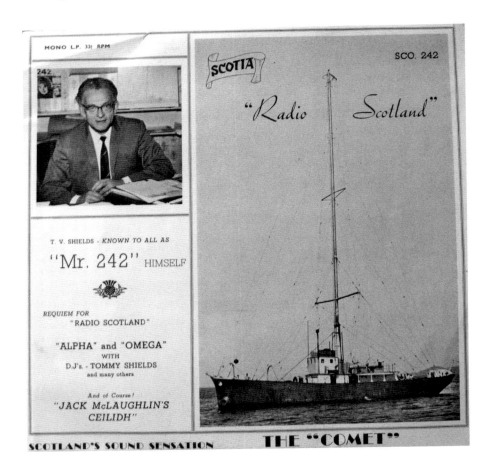

MONO L.P. 33⅓ RPM

242

SCO. 242

SCOTIA

"Radio Scotland"

T. V. SHIELDS - *KNOWN TO ALL AS*

"Mr. 242" HIMSELF

*REQUIEM FOR*
"RADIO SCOTLAND"

"ALPHA" and "OMEGA"
WITH
D.J's. - TOMMY SHIELDS
and many others

*And of Course!*
"JACK McLAUGHLIN'S
CEILIDH"

SCOTLAND'S SOUND SENSATION

THE "COMET"

A 78 with a 78 in '78. He's looking for a hi-fi.

Pirate radio was an illegal and Government resisted answer to the boring range of radio programmes available in the '60s, and Radio Scotland was an astonishing change from listening to Lonnie Donegan on the jukebox. For our more modern readers, the jukebox was an electro-mechanical device standing about 5 feet high and 3 feet wide. What you would do was insert the required currency and select songs. These were on old style 45-RPM discs and when you pushed the button to select a song, an arm would come out, lifting the record from a rack and depositing it on the turntable. This must seem a long way from the MP3 player.

Radio Scotland brought music into our homes and with the new transistor radios you had an alternative to the Home Service. Perhaps the most famous of the presenters was Jack McLaughlin with his ceilidh. Radio Scotland broadcast from *The Comet,* a former Irish lightship built

at John Brown's on the Clyde. It began broadcasting at 11.50 p.m. on Hogmanay 1965 and continued until it was silenced on 14 August 1967. Overleaf (page 54) is an album produced as a requiem for Radio Scotland. It features such presenters as Stuart Henry, Tony Meehan, Bob Spencer and Tony Shields, 'Mr 242' himself. The album included 'We're no awa tae bide awa' but unfortunately they were.

However, some of the broadcasters like Stuart Henry and Jack McLaughlin went on to have successful careers at other radio stations. This album is truly part of Scottish musical history.

Although the Government had succeeded in closing down the pirate radio stations, our appetites were whetted and the BBC had to do something to meet the demands of those who had been listening to pirate radio and Radio Luxembourg. They finally produced Radio One and *Top of the Pops* that were to go on to be institutions.

# Just for Jazz (and Big Bands)

While jazz has had a resurgence in Glasgow lately, in the 1970s it had waned in popularity and struggled to survive the 'Swinging Sixties'. Its connection with the 'Beat Generation' of poets and black polo necks didn't help. In the late '50s it had gone head to head with skiffle along the lines of 'mods and rockers'. It barely survived the Pearl Carr and Teddy Johnstone era ('Sing, Sing Little Birdie').

I remember being taken to the bohemian Papingo coffee bar in University Avenue by my father. That's gone and so is the trendy La Ronde. The continuation of jazz in Glasgow was due to a small number of hardy enthusiasts like the Clyde Valley Stompers, who are still going strong. I also remember with affection Bill Fanning's Saxes and Sevens playing in The Strand and other city centre lounges on Saturday and Sunday afternoons. Bill Fanning, from Scotstoun, was an eccentric in many ways but his dedication to keeping together a big band of mostly professional people was truly inspirational.

Talking of eccentrics, you can't talk of Glasgow and jazz without mentioning George Chisholm, who was born in 1915 into a musical family and who started his professional career in the Glasgow Playhouse. Throughout his long career he played with such famous names as Ambrose & His Orchestra and the Kenny Baker Dozen. He was also a founder member of the famous Royal Air Force Squadronaires that are still going strong. And I can confirm this as I danced to them at the 2010 Edinburgh Blues and Jazz Festival. They were brilliant. What a legacy!

He was a brilliant trombone player but my memories of him are more of his wit and humorous approach to playing jazz, which did not always endear him to colleagues. He was a regular on *The Goon Show* and often worked with Spike Milligan. One of my favourites is *Ding, Dong, the Witch is Dead (Please Do Not Smoke)* featuring the Goons and George Chisholm as trombonist. It is wonderful. George died in 1997.

# Take a Drink!

He went intae a pub, cam oot paralytic,
Oh oh, Lanliq and the cider
Ah haw, what a helluva mixture,
Cod liver oil and the orange juice ...
(Ron Clark and Carl McDougall)

For the baby boomers, the '70s were the rites-of-passage years. They say that if you can remember the '60s then you weren't there! Well, strangely enough I remember them very well. It is the '70s I am a little hazy about.

I certainly remember the smells of the '70s, the most prominent being new concrete. But in terms of pubs, every one had its own unique smell, of course including the reek of cigarette smoke and beer. The one smell that everyone will remember is the guff of wet Afghan coats piled in a heap round the backs of chairs or heaped up on the floor where they would dry and give off a rising smell akin to dung. It was known that in many cases, the skins for some of the cheaper coats had not been properly cleaned and they stank like anything, as well as sometimes producing maggots. I remember the unlikely picture of a hippy dressed in an Afghan coat coming into the pub with an Afghan dug. They say that dugs look like their owners and that was certainly true of that incident, except I thought it was a bit cruel to bring the dug into the pub to be confronted by a pile of coats that looked awfully like its own. Not nice at all.

The rites certainly allowed for copious amounts of alcohol being dropped down the passage. Being poor students and such, the drink had to be of the cheapest available, and I remember getting a postcard from the lads in London. All it said was: 'Merrydown in 6 flavours'. Merrydown being the cheapest drink at that time, if you exclude such delights as plastic gallons of cider that you could buy from the Sarry Heed (Saracen's Head in the Gallowgate) still with sawdust on the floor at that time. A whole busload of us stopped at the Sarry Heed and delighted in that cider on a bus run to Dunbar. I think we were in oblivion by Edinburgh.

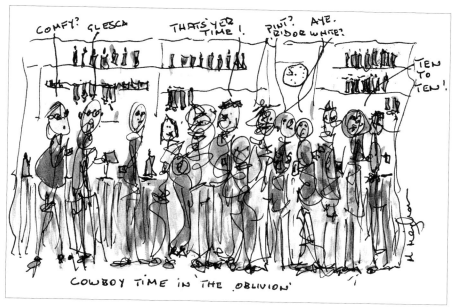

Cowboy Time!

I was working in The Strand one quiet night when two punters came in, rather the worse for wear and I debated whether to serve them. Cowardice got the better of me so I gave them the two whiskies that they wanted.

Now every Glasgow pub had given up using the water jugs supplied by distillers and brewers, as they would just get 'knocked', even the ones for Watney's Red Barrel. We used old Courvoisier brandy bottles, which we filled fresh every night.

Now you might think that using brandy bottles was rather posh but do remember that brandy and Babycham was a drink of choice for ladies in those days. I'll come back to that.

Anyway, the two punters, having been furnished with two large 'Black Labels' debated between themselves whether the water in the bottle in front of them might be fresh.

'Ah'll tell you if it's fresh' said the one, putting the bottle to his mouth and pouring a liberal quantity down his throat. 'Aye, that's ok,' he said.

Enough's enough. 'Drink up and leave' I said.

And you know what was weird? They looked at me totally mystified as to why they were being ejected.

The other extraordinary thing about The Strand was that it actually did sell Watney's Red Barrel.

It also reminds me that in the same pub there was a barman who was caught with his hand in the till. He said that he 'needed the chinge'.

If ah hud twice his sense I wid be a halfwit!

Oh Aye. brandy and Babycham. It was a Saturday night and we had all arranged to meet in the Granville in Sauchiehall Street before going on to a students' charity ball at the Locarno. Anyway, I was first in and sat down just as Colette and Pat came in and I offered to buy a drink. Brandy and Babycham was the drink of the moment then. So off I went to the bar, just as Nancy, Angela and Sadie, and two other girls, came in and I in boyish embarrassment and misplaced gallantry got them all brandy and Babycham. Very benevolent, I am sure, but do you know then what happened? As soon as the lads came in someone suggested a kitty! Do you know how much was a large round of brandies and Babycham? Gallant fuck all! I should have done a runner with the kitty. And by the way, 'being light in the kitty' didn't mean that you were nice to cats. Someone had not chipped in!

The pubs in Glasgow were nothing if not pretentious, often with names both romantic and valorous. There was The Avalon, The Amphora, The Alhambra, and The Rubáiyát (of Omar Khayyám), which was disgracefully closed and re-opened as a bistro called 'Otto'. It used to have, inscribed above the bar, a verse from the famous Eastern poem as translated by Edward FitzGerald: 'The moving finger writes; and having writ, moves on.'

It was a great place for the pretentious student *Guardian* reader. There were also 'pseuds' pubs like The Rock. 'Pseuds' being those students who thought they were a cut above the rest of poor Glaswegian students. They came in from 'the spam belt' – (fur coat and nae knickers).

Actually, while we are talking about pretentious pubs I do remember a couple that were the place to go and were actually very innovative. The Muscular Arms in St George's Place was on two floors and I think the windows were covered in cartoons such as Mickey Mouse until Disney objected. I was only in it once as I think you had to wear a tie!

Now the Lunar Seven was at the top of Buchanan Street. It was all tinfoil and starlight. I hated it as it was always dark and you couldn't hear yourself shout. Anyway there was a murder there in 1977 and it closed not long afterwards.

Oh and we drank very pretentious and exotic mixtures such as Guinness and orange juice, black rum and pep(permint), snakebite (lager and cider), black rum and blackcurrant.

Pubs were not just for drinking. They were social clubs and meeting places. You needed somewhere specific to meet before you went off to a party or whatever. You didn't have a mobile phone then to find out where others were.

There were plenty of things to do. There was darts or dominos – 'middle for diddle' they would say to kick off the latter.

There was a game we played with beer mats. We placed them on the edge of the table, with the mats slightly over the edge and then flicked them into the air with a hand and then caught them. The winner was the one who could do it with the most beer mats. I think I got to about twenty. Of course you were apt to piss off those who were sitting without beer mats, as well as the publican.

I have recently been told that many bars don't have beer mats any more for hygiene purposes. What are you supposed to do then for fun? And what about the darts? Are they not as dangerous?

We also did the quiz from the *Evening Times* or the Salvation Army's *War Cry*, which they sold when they came round the pubs. This reminds me of the wee Glasgow man who found a brown paper parcel in the street. When he opened it, inside he found a Salvation Army uniform and a collection can. He thought that Christmas had come as he donned the suit and went into Lauders filling up the can with very little trouble. When he thought he had enough money he would take the uniform off and then go and drink the proceeds. In this way he had done quite a lengthy pub-crawl up Sauchiehall Street taking in Mackintoshes and The State. By the time he got to The Ritz he was well away and struggling to keep up the pretence as he went round the punters with the can. On his way out of the door, some punter called out to him: 'What about The *War Cry*?'

'Geronimo!' he shouted.

Of course on leaving a pub nobody ever said cheerio. You were most likely to be addressed by one of the following:

> 'If ah don't see you through the week, I'll see you through the windae.'
> 'If ah don't see you roon aboot, ah'll see you roon a shoe.'
> 'Ah'll see you when you're better dressed.'
> 'No if ah see you first!.'

And I would retort:

> 'It's no often youse are right but youse are wrang again!'
> 'It takes wan tae know wan!'
> 'Dae ye think it's ootside yer in?'
> 'If ah don't see you again it'll be too soon!'
> 'Pick a windae. Cos yer going oot wan.'
> 'Dae ye want tae pick up yer heed wi a broken erm?'

Now, you were in luck if you had a pal who managed or owned a pub because sometimes you got to stay late while the doors were locked. I don't mean in the Highland way, in which the pub is busier after the door is locked than before it.

'McEwans is the best buy, the best buy, the best buy. McEwans is the best buuuuuuuy, the best buy in beer. Aye McEwans! The best buy in beer' Sing along now!

Anyway, I had a pal who managed Drybrough's Corn Exchange in Gordon Street (remember Drybrough's – terrible beer). At a weekend we would congregate in the bar and then we might stay on a bit after the bell unless we were going to a party. Well one night there were two or three of us in the pub and we had just helped clear up and we were having a pint. There was a knock at the door. McB went to the door and there were two polis. I recognised one as Big Red, who was well known. They had stopped in to cadge a free drink that McB proffered. We had a fair old time when suddenly there was another banging at the door. The two bobbies shot down the stair to the lounge while McB opened the door. Jings! It was another two bobbies and there were a few sweary words as Big Red's head came round the corner. 'God, you gave us a fright there,' he said to the newcomers. Apparently the Chief Inspector was out that night and they had been trying to avoid him. The temptation of a pub with its lights still on was too good to miss. Now we continued to have the same good time till again there was another banging at the door. Yes – you guessed it – another two policemen with the same intentions. You would hardly believe it if you hadn't been there and I was there so you can believe me. Are you calling me a liar?

Anyway, it appears that Gordon Street was where there is an overlap of beats (when you used to have beats) and that's how we came to have six polis in the shop after hours. We got chatting and I told them my story of how I had kicked a polis in Anderston when I was very little, (See *Glasgow Smells*). They went quiet and I have to tell you that I think the handcuffs would have been out if they weren't all breaking the law. I was scared for a bit but they were good enough to drive me all the way home to Knightswood when they left.

While we are about it, it reminds me of the story of the wee Gorbals man who poured Domestos over the two police constables. He was done for bleach of the police.

Actually I do remember an involvement with the police when I nearly became a film star. Around 1972 I had a period of unemployment in which I tried to occupy my time as best as I could. I came across an advert in the *Glasgow Herald*: 'Do you want to be a film star?' Well of course I did. Every Glaswegian wants to be a film star. So I sent a letter off to the address on the advert and got a very, very strange reply asking me to send a pound for administrative expenses and I would then be interviewed and so on. Well, excuse me; did they think that I came up the Clyde on an Abernethy biscuit? Sorely disappointed I phoned the Glasgow CID to enquire about their feelings regarding this. I got a very nice response asking me to come in for a wee word.

I did so and was shown into this office in which were two detectives poring over newspapers looking for articles such as what I had replied to. It was good to see that there was vigilance afoot.

At this point, my new chum showed me a tea chest (surely I don't have to explain what a tea-chest is?) that was about two-thirds full of what seemed to be opened envelopes. 'Do you know what that is?' he said.

'No'.

'That's the mugs that actually sent the money which has been spent on an ongoing basis by the perpetrators' he said. He went on to explain that they routinely inspect newspapers for such adverts.

And I really wanted to be a film star. I could have had a career there.

# Back to the Pub!

One of Glasgow's best-known landmarks is the Art Deco building that was known as the Beresford Hotel, then latterly the ICI Building before becoming the Baird Halls of Residence, and then private apartments. Apparently they had to, as students were getting too good at throwing washbasins onto Sauchiehall Street. At the bottom of the building was The Beresford, which became the haunt of American sailors from the Holy Loch and ladies who wanted to meet American sailors from the Holy Loch to cement international friendship and further the 'Special Relationship'. Hmmmmm.

The Holy Loch was the site of the US Polaris missile base between 1962 and 1992, when it was considered unnecessary due to 'the Peace Dividend'. The base was featured in both *Ice Station Zero* with Patrick McGoohan and *Red Storm Rising* starring Sean Connery.

This reminds me to tell you a story of the shepherd with a flock of sheep that was grazing beside the American submarine base in the early days of the base on the Holy Loch. One day, some of his sheep strayed through a hole in the perimeter fence and he naturally went after them.

While chasing them he was stopped by a security patrol in full naval gear.

'Stop. We're arresting you as a spy' said the officer in charge.

'But I'm only a shepherd after my sheep' said the shepherd.

The officer thought for a moment before replying: 'OK. We're arresting you as a shepherd spy!'

My cousin Raymond did tell me a true story that in the early '70s he and his children did actually stroll onto the submarine base right up to a submarine before they were challenged by an amazed sailor.

The Beresford Hotel.

The USS *Proteus* loading a nuclear missile onto a submarine in the Holy Loch.

# Back to the Bar!

It was the Great Reo Stakis that revolutionised the way we drank in Glasgow (the way, by the way, not the amount). Prior to the opening of the Stakis Olde Worlde Inns and Steakhouses, the choice was either the traditional pubs with their traditional toilets and traditional smells, or the posh hotels, where you often had to wear a tie and try to look both sober and respectable. You know, the sort of place that you would go for weddings, and for people to embarrass you.

'See you – I cannae take ye anywhere!'

'Aye ah could take ye twice – wance for you tae make an arse of yourself and wance tae apologise!'

You had to be on your best behaviour and of course this is where they spoke the best Glasgow French:

'And what can I get youse Modom?'

'Whit ye want hen?'

'Wan o they Moscow Mules and don't forget the maraschino!' (With the emphasis on the *i*.)

Don't forget the 'quietly sophisticated cocktail bar!'

# The Kerry Oot

At the Last Supper, Matthew said to Peter, 'Whit's that under the table?'

'That?' came Peter's reply, 'That's Judas' kerry oot.' The kerry oot was sacrosanct and to be protected at all costs. Remember that in the 1970s we were still in a period of relative prohibition. Although the pubs were now open on a Sunday, they all shut at 10.00 p.m. and you had to start drinking up at cowboy time (ten to ten). It was even worse in some 'dry' areas such as Knightswood and Langside.

The licensed grocers also closed at 10.00 p.m. and had to be pretty strict about not serving anyone after 10.00 p.m. under pain of losing their license. Added to this of course, the supermarkets did not then supply alcohol, so you were confined to a very limited number of off sales (or licensed grocers as they were called then). If you didn't get your act together you might have to pay the full whack for pub beer and spirits as they (they said) were required to sell it to you for the price that they would charge if it was sold over the bar. If I remember right, there were twenty-six nips in a bottle that could set you back about twenty quid. So if you didn't get a move on you were stuck.

Now the kerry oot generally had a standard, recognisable shape, particularly that used for first footing at Hogmanay. You got six cans together, standing up in a sturdy brown paper bag identical to those in which your curry now comes. On top of these would be laid a half bottle of Bells wrapped up in greyish white tissue paper. And because in those days there were no sook-easy cans, you would be provided with a steel multi-purpose tool about 4 inches long, one end of which was for opening bottles. The other end had a triangular steel point for opening cans. If you were a ned, this could be used for self-defence purposes if your sharpened steel comb (or chib) had got blunted (or so I have been told).

I remember McB being apoplectic for a long time after one night in a hostelry in the Shaws. He had been there and had met H. and his girlfriend. H. had sworn poverty so McB had subbed him to drinks over most of the night. Now cowboy time was upon them and H. and girlfriend made their

apologies, as they had to leave to go to a party to which no one else in that company had been invited. To McBs consternation and amazement H. lifts up from under the seat what is clearly the formulaic kerry oot and departs with girlfriend. As I say McB was stunned and may still be as far as I know. But it illustrates the point. The kerry oot always takes priority.

Hingin's too good fur him!

# The Party Piece

Now on to the party. Everyone had a party piece that they were expected to perform even though it might take some alcoholic lubrication to get them started. They were wild and varied. I think that it was Frank MacAteer who appeared through the front door one night with a pair of black shoes firmly strapped to his knees. He wore a black coat down to the floor and with a bowler hat he did a wonderful Toulouse-Lautrec impersonation.

Frank Bannigan sang 'It Was Only a Shanty in Old Shanty Town' and he would engage others to form a barbershop quartet. Big Kevin did a brilliant impersonation of Eamon Andrews in *This is Your Life*. Big Kevin (snr.) did a fantastic version of Elvis's 'I'm All Shook Up'. Sadie and Angela gave us a great rendition of 'Kelly and I meet secretly, we stay out of sight...'(Ref. Del Shannon). This was sung in close harmony. It wisnae harmony but it wis close!

My party piece was 'The Whip' which I have to say I was pretty good at. The Whip was a little play in which I took both the part of the torturer (T) in the castle dungeons as well as the poor prisoner (P). This involved me alternately cowering on the floor or standing over the prisoner with an air whip. It demanded some stamina I can tell you:

| | |
|---|---|
| T | The Whip! |
| P | Not the whip! |
| T | Yes – the whip, the whip! |
| P | Please not the whip, not the whip |
| T | Yes – the whip, the whip, the whip! |
| P | No, no, anything but the whip! |
| T | (*thinks*) Anything? |
| P | The whip! The whip! The whip! |

'The night drave on wi' songs and clatter
And aye the ale was growing better'
(Ref T. O'Shanter)

Eventually the party would break up, usually because the drink had run out or people fell asleep. There was one memorable occasion in which the party came to an abrupt end when one chum who had had rather too much to drink and who had previously crashed out suddenly reappeared, apparently sleepwalking, to pee into the hi-fi. Now this is not one of those 'friend of a friend' thingies. It was not me. That was much later. I might tell you about it if pressed.

Now in case some of the younger ones among you are wondering what is a 'hi-fi'? Remember this was not yet the digital age and in the '70s, we still had either the Dansette record player or the high fidelity unit which was just a posher version of the Dansette, but usually with a radio attached. I found the version blow at an auction. Those revolutions revolutionised our evenings.

Back to the party. Unfortunately if it was the kind of party where you couldn't crash out on the floor for any reason, you had to start the long journey homewards. That was not so bad if you lived close at hand but you were apt to find yourself at the wrong end of Glasgow at a very early hour in the morning without a night bus in sight.

This happened to me on several occasions when I would wend my weary way home to Knightswood at the dawn hour. On one occasion I did the

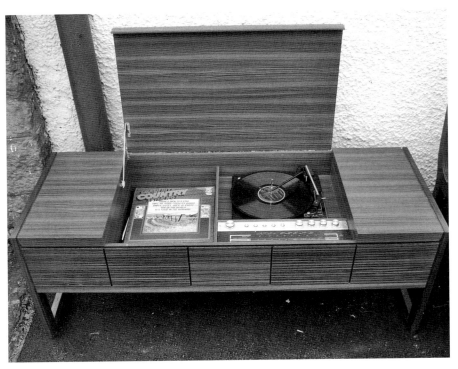

The hi-fi is drying out. The country music is still a bit wet.

walk through the Clyde Tunnel. They then, and maybe now, open only one of the tunnels during the night while carrying out maintenance in the other. So there I was attempting to walk straight down the white line in the middle of the tunnel to pass by a lorry on which were two guys fixing lights.

'Aye,' I said.

'Aye,' one said.

'Aye, aye,' the other said and I wobbled on. It's nice to be nice.

On another occasion I was so bored walking along the Great Western Road that I wondered how long I could walk with my eyes shut. It didn't take long till I found out, as I walked straight into a lamppost and had to sit down at the side of the pavement to gather up my senses, my head and my broken glasses. Stupid bastard!

Meighan, yir a fool to yirsel and a danger to ithers!

One memorable night I was in the Shaws for a New Years party. I had left the party about 5.00 a.m., probably because there were no floors or drink left. Anyway, there was I in Pollokshaws Road ever-hopefully thumbing a lift. And to my surprise the first car that came along stopped and I got in, thankfully, after the driver confirmed that he was going to the centre of Glasgow. Remember that that was in the '70s and hitchhiking was commonplace and safe (until it wasn't safe).

Anyway I got talking to this very nice chap who said that he was heading for his mother's in Govan, I think, and was going to take in the New Years Old Firm Game between Celtic and Rangers. Anyway, we got talking away about life and this and that and he said as he was on the road he would just take me to Knightswood. Careful now! It was nothing like that. We were just chatting away. Of course, by this time I had realised that there was something familiar about him. So as we were old pals by then, he rather amusedly told me that he was Pat Crerand, the famous Celtic and Manchester United player.

My father was doubtful and my brothers were furious. 'You don't even like football,' said Martin. 'Did you get his autograph?' Jealous bastard.

Pat had six years at Celtic Park before signing for Manchester United in 1963, playing with George Best, Denis Law and Bobby Charlton. He retired in 1972 which must have been around the time that I met him. He had appeared 401 times for United. He went on to manage Northampton Town and then onto football broadcasting. By the way, Pat wrote his own book: *Never Turn the Other Cheek*, A legend. Nice to meet you Paddy.

And before I leave the subject of alcohol, I think that I should tell you about a very strange and deeply depressing letter that I received around about the time of my misspent youth, which I think lasted a long time. Out

of the blue I received a letter from a Reverend T. Witherspoon and it read like this:

> *The Reverend T Witherspoon*
> *The Rectory*
> *Lambeth Road*
> *London*

*Dear Michael*

*Please forgive me for writing to you unannounced but I have to let you know about the death of my assistant Alfred.*

*At our church here in London we have a mission to spread the word about the evils of alcohol and how it can lead to a world of sin and degradation, how it can bring down everyone around those affected by it as well as lead to moral turpitude and sloth.*

*To assist my sermons on this subject I engaged the services of one Alfred Higginbottom of this parish who amply demonstrated all of the above conditions.*

*As I talked to our congregation, poor demented Alfred would sit slobbering and gibbering at the foot of the pulpit, begging to be given drink. He would sit in a puddle of his own making tearing out his hair and screwing up his face and contorting his emaciated body. Well naturally, in such a state no one can go on forever and sadly very recently it was a merciful kindness that poor Alfred passed away.*

*That of course has left a gap in our lessons. A mutual friend has suggested that you might in time be an ample substitute for poor Alfred. If this is the case we would dearly like to welcome you to our lovely congregation.*

*I remain etc.*

The thing is the signature looked strikingly similar to big Kevin's. Bastard!

Before I leave the subject of drink I must tell you about the time that I was an advisor on alcohol to the Secretary of State for Scotland, Willie Ross. I was working in the bar of the Douglas Hotel in Aberdeen, which was hosting the Scottish Trades Union Congress conference. Willie Ross came into the bar along with the famous Scottish Miners leader Mick McGahey. They both came up to the bar and asked what was the best beer. I said, 'That would be your Tartan Special sir!' I could have had a career there.

# Fine Dining

You couldn't spend all your life in the pub although there are those that could argue otherwise. Occasionally you had to bite the bullet and invite a girl out to dine. For the young Glaswegian who was used to the 'fish tea' or maybe even the posher 'high tea', going beyond the bounds of these traditions was sometimes a scary experience particularly for the young man who had asked a girl out for the first time to a restaurant after first of all meeting her at Boot's Corner or The Shell in the Central Station.

The '70s were a time of great culinary experimentation and innovation. First of all there came along the Reo Stakis organisation that revolutionised the way we ate. In the Alpha in St Vincent Street or the Pond Hotel on the Great Western Road you were able to feast on cremated Aberdeen Angus and chips washed down with a wee Blue Nun before moving on to Black Forest gateau. 'That wis rerr.' I actually used to think that wine came in red, white and blue. They never had a Red Nun when I asked. Come on. I'm no that daft!

Henry reminds me of Steakhouse 10 in Gibson Street, where he was a vegetable chef. That's not a nice thing to call your customers! No wonder it closed. Apparently it was a favourite watering hole for many BBC people and personalities including Stanley Baxter and Stuart Henry, who had a cool way of talking. Stuart was dining 'à deux' when he was joined by a third person. Stuart came up to Henry at the bar and said, 'Cancel the pork chops ma friend' and *soto voce* 'chap's Jewish,' (as was he I believe). Stuart Henry was a personality in those days and a mainstay of the new pirate Radio Scotland. His catchphrase was 'Allright my friends.'

Stuart joined the new Radio One at its launch and eventually moved to Radio Luxembourg. Unfortunately he developed multiple sclerosis and died in 1995. He is well remembered in the Radio Academy Hall of Fame and for his work on behalf of MS research. You can download extracts form his shows on *www.radioacademy.org.uk*. It fair takes you back my friends.

Stuart Henry, courtesy of Jon Myer.

Not that there were many exotic places to go to. I ate my first pizza in La Roma Italian Restaurant at the corner of Hope Street and West George Street. That's when I discovered that anchovy was a fish and see me! See fish! Why would anyone want to put fish on a pizza?

Talking of Italian food, it was McBeth's sister Maureen that first introduced me to spaghetti bolognaise during one of our group rehearsals at her house. Funny how you remember that, but to someone who thought that spaghetti was orange and came in tins it was a pleasant surprise. I also remember my embarrassment in an Italian restaurant. I had gone on a date and had splashed all my money on cannelloni before realising that it was only a starter.

There was also the time when a girl I had taken to a bar had asked for a whisky and soda. Well, putting soda into a whisky glass from one of those old soda siphons is an art that has to be practised. I did so with too much pressure and the soda went into one side of the glass and the whisky came out of the glass and mostly over the bar. Thankfully she didn't say much. Maybe she thought it was an English measure. I do remember my uncle telling me that the first time he had ordered a whisky in England he thought that he had been given a dirty glass.

Before our attempt to posh up, going out meant a fish tea, which was basically a fish supper served on a plate, supplemented by a pot of tea and white bread already buttered. The upmarket high tea was brilliant. It was served by waitresses in black dresses with starched white aprons. They served your fish and chips or gammon steak on huge plates on crisp white tablecloths.

The pièce de résistance (there we go again) was the cake stand that held a standard selection of scones and cakes of which there was always a fly's cemetery, an Eiffel Tower, a fern cake and a French fondant. My favourite was always the Eiffel Tower and often you had to fight for it, although fighting in the posh tearoom was frowned upon. 'Hey youse, behave yirself.' 'Shut yir geggie ya wee nyaff' or pleasantries like that, said in dulcet tones.

The baby boomers also had to cope with the introduction of the fondue set that never really took off, although I did see one explode at one time. Some people got really cheesed off.

Of course, buying wedding presents then was very easy. Besides the fondue set there was the Sparklets Syphon, the Soda Stream, the electric coffee percolator and the sheepskin rug. Of course, if someone else had got these, you could always get the toaster. We got five. Paul and Angela got three pressure cookers. That's some pressure.

The Glaswegian didn't have any difficulty at all in taking to the curry. It was as if Indian and Pakistani food was lying in wait for us to discover. How it took so long I don't know, but we have never looked back.

*Above left:* This was my limit.

*Above right and Below:* Too Posh for me.

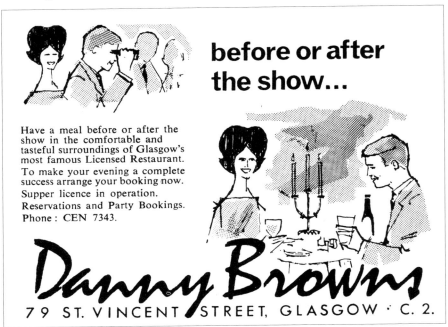

De rigeur after ten pints of Guinness was a curry, in the early days in the Green Gates or the Shish Mahal. There we would experiment with the vindaloo and the stuffed paratha, the lady's fingers and the pakora. In the morning we would experiment with the aftermath and the sound effects.

Of course some would get it for free if they had the courage. This was called 'the runny oot'. Three of us were landed with a bill one night when Big P did a runny oot. There we were just finishing off when Big P suddenly wasn't there and the door to the Green Gates was swinging. Bastard!

We made friends with the Asian and Chinese restaurateurs and they have become as much a part of the city as the Italian café's did. But now we are in a world of lattes and cappuccinos and we eat nachos and paninis. We have come a long way.

I wonder whether 'Irate Homeowner of Shawlands' is still around and what he/she thinks of the restaurants now. In July 1975 the *Evening Times* printed a letter from the above: 'That's just how Glasgow smells ... Glasgow is gradually being turned into a "stench Mahal" as it literally stinks of curry ... With a little imagination you could be in Delhi or Calcutta.' Oh dear! I do hope that we have moved on from that kind of sentiment. Glaswegians were generally accepting of refugees and immigrants, many of them whom we began to rely on for the curry and for the corner shop. We were only vaguely aware of the conditions that had made them flee their own countries to settle in Glasgow.

A couple of years ago, in a conversation with my daughter, I said that I once had a friend called Sali. That was a conversation stopper.

'You mean a girlfriend?' said Catriona. 'No. Sali was a bloke, from Uganda'.

I went on to explain that in 1972 I had gone back to further education college at Langside to get a few 'Highers' and one of the people that I met there was Sali. I can't remember how our paths actually crossed but I found out from him that he was an Asian from Uganda where there were many Asians. His father ran an electrical company and Sali was over studying electrical engineering. Perhaps that was how we got talking as I had been in electronics. I remember giving him my copy of *Electricity and Magnetism* as I didn't need it any more. We got on really well and I visited him a couple of times at the YMCA off the Great Western Road, where he was staying. This was a new thing for me as his pals there were all coloured and I had never known even one before.

'What happened?' Catriona asked.

'Do you know I don't really remember. I didn't finish the last term after exams and we lost touch'. I wondered, though, what had happened to him, because in Uganda in January 1971, Idi Amin came to power through a military coup. You know the film *The Last King of Scotland* with James McAvoy. Forest Whitaker won an Oscar for his role as Idi

Amin. Well that was all about Idi Amin who aspired to have Scottish connections.

His reign was known for terrible human rights abuses, persecution and famously for the expulsion of Asians from Uganda. It is estimated that up to 500,000 people had been killed as a result of his regime. I often wondered what had happened to Sali and his Asian family. But you know you often don't keep in touch with people that you meet. With Sali I wish I had, because he was a quiet pleasant chap, probably completely different from me. He probably challenged the kind of small and parochial prejudices I came across in Glasgow at that time. Just like 'Irate homeowner of Shawlands' he must have been 'ane o they queer folks fae the 'Shaws'. It was the kind of thing that also turned me away from any thoughts of nationalism. It was lovely to have known you, Sali!

I particularly like Chinese restaurants. It was Big Kev who introduced me to the delights of 'the businessman's lunch'. You could get a 'special' curry that was special by dint of it having a fried egg on top. One of my favourites was The Sam Pan in Renfield Street. That reminds me of the harp player in the Glasgow Chamber Orchestra who got 'a bit worse for wear' while playing in Hong Kong. They had been in a nightclub called The Sam Pan. He was unable to play the next night as according to him, 'I left my harp in the Sam Pan Disco.'

More representative at the 2010 Great Scottish Run.

Byres Road – still going strong.

Glaswegians will relate to this in many ways!

By the way, a Glaswegian I know moved to Germany where he opened a Chinese restaurant. He called it 'A Wok in the Black Forest'.

I told that to chums in Glasgow and one said, 'I don't get where the gateau comes into it?'

# Trouble

You were best to keep out of trouble, as I have said so often to those on my 'handling violence' courses. But you know you can find trouble if you look for it. When I worked once in a pub in Hope Street there was a sad man who was a real bully to the staff and couldn't finish the week without promoting a real battle. To this end he would shout, 'Time please,' and then immediately start lifting pints. You know you can only do this so often in Glasgow until someone takes real umbrage and makes an objection (as in 'any obs pal').

Anyway, you try to avoid danger but that can be quite complicated if you have the munchies after a night on the Tennents. And this was the case one night at Taam's hoose in Kinning Park, where we were having a party. Anyway, at the cross, where there is now the Grand Old Oprey (original or what), there was an unhygienic pie van selling unhygienic pies. You know – the wans that wid take your face aff wi wan bite, the crusts were that sharp.

So it was there one night that a few of us approached the said maroon caravan to purchase the said fat pies. Now this caravan was known as the 'fo bob man' because the pies cost a good 4/- (remember that symbol) and he would hand the pie to you and simply repeat several times 'fo bob, fo bob, fo bob'. I have often wondered if his name was Simon?

I was in the process of attending to a pie that I had purchased when a bad boy came up to me – probably a Glasgow ruffian like those we hear so much about in those scurrilous books like *No Mean City*. The bad boy said to me in a very mean tone, 'Heh. Gie's a bit o'yer pie pal.' Now do try to imagine this with a nasal intonation such as you may have come across in the Robert C. Nesbitt stories.

Anyway, I was never one to be trifled with when in a tight situation. Andrew L. will tell you that, having suffered a broken nose at my hands when he was younger. Anyway, survival of the fittest and acting like a cornered rat were the scenarios that would later come to mind when I studied ologies. In these situations, speed is always of the essence, as he who hesitates is lost. So without further ado I pushed the mince pie straight

into the features of the person who had been accosting me because I knew full well that giving a piece of pie to such a person would be the prelude to sharing with him the contents of my wallet, my fags and anything I might have left after a night on the town.

I did not wait to examine the consequences of my actions but along with two fellow pie eaters, I hared it through Kinning Park till we thought we had outfled him and his henchmen. It may have been a slight moment of violence in my past but you know I am almost heartened at the thought of the good effect my hot mince may have had in unblocking the dear chap's nasal passages and making him very wary in the future of laying claim to midnight's pies.

So that was the 'Fo Bob Man' cementing my understanding that you must at all costs stay away from troublesome areas in Glasgow if you are to avoid difficulties with the natives. I can in fact illustrate this clearly using the example of my dear son, whom you may have encountered in previous works by the author. It might be known that I left Glasgow behind to make my fortune in the Highlands and there we brought up two children. However, you can't remove the heritage and my boy developed an affinity to the Dear Green Place.

My son now stays in Amsterdam but did bide in Glasgow in his younger, student days. On first venturing from the dear old Black Isle he went forth to examine the Strathclyde University campus with a view to taking up residence there. Now his first preference, possibly because of the nearby presence of a

More modern and more expensive – but less literate!

biggish music shop, was the Bruce Halls that had previously been the Royal Stuart Hotel on the Broomielaw at the bottom of Jamaica Street.

Anyway, this is not a salubrious area at night, particularly for a young Highland innocent. So we put the veto down and gave it the big 'E'. He was persuaded to attach himself to a rather nicer little place in Cathedral Street, just round from where I was schooled and his grandfather taught. So all was well until at the beginning of his second year, he had quite rightly decided to move into a flat with chums. 'I've got a flat,' he said.

'Oh good' I said, but with some hesitation, to the trainee Glaswegian. 'Where?'

'In Duke Street' he said.

'Whereabouts in Duke Street?' I asked, with a fearful gripping sensation round my heart and my ears pounding.

'Dennistoun' he replied. 'And' he said, 'I have a part time night job in a pizza factory'.

Again I replied 'that's good', with a definite tremble in my voice. 'Where is it?'

'It's in a place called Possil,' he answered.

Well, excuse me here if I offend anyone who lives in either Dennistoun or in Possil, for that is not my intention, but what sort of a father would I have been had I not remonstrated with my poor innocent offspring who had taken a flat with the intention to travel in the night-time from Dennistoun to Possil? Particularly since he regaled me with the fact that a pub just round the corner had been firebombed the week before. Get real. 'Chris', I said, 'wise up. If I have to come down there and...' You know. 'Children, you give them everything and what do you get....' (Ref 12 Angry Men with Henry Fonda)

The solution was not long in coming. I wondered about keeping this sorry state from my dear partner and mother to the aforementioned new east-ender. Apparently, the Turkish landlord did not appear to be bona fide in his dealing with our son and began to demand additional monies. At this stage son became acquainted with the famous 'doing a moonlight' and got a flat in Partick, where he should have been in the first place. among the others of the Gaeltacht.

Now, before those nice people in Dennistoun get angry with me, I have to tell you that after some protestations (from Catholics as well), I decided to visit the village of Dennistoun and check it out. Well, I apologise. Dennistoun turned out to be much improved. After walking from the Barras, I had a very nice lunch in Coia's before embarking on my trip over Alexandra Park and on to my old stomping ground of Robroyston. I have to tell you that it was very nice indeed, except for the litter. I was also very pleasantly surprised by the street sculpture at Provan.

More recently I took a party of cosmopolitan pals for fish suppers at Coia's and their reviews were very positive. Except that Lesley said that she

Sculpture at Provan.

Entrance to Tennents Wellpark Brewery. The Tennent's Girls are a piece of male chauvinist history and they can be seen here.

Coia's in Dennistoun.

had never been sworn at by a waiter before. 'Calling you a "daft bugger" is not swearing' I replied. It's a friendly sort of a place.

We wandered back to town and I showed them the Tennent's Girls still on the mural at the entrance to the Wellpark Brewery. I pointed out the Great Eastern (a hotel), which has been restored and converted to flats. The 'hotel' label was always fictitious, as it was a model lodging house. I showed them the remains of the wall of the Duke Street women's prison, where, in 1923, the last woman to be hanged in Scotland was Susan Newell, for strangling a paper boy.

# Neds

If I had lived all my life in Glasgow then the question would never have arisen, but arise it did as Henry and I wandered the Highland glens with some locals of those parts. 'But what exactly is a "ned",' says Shuggy.

Well I looks at Henry and Henry looks at me. 'Well,' says I. 'Henry, coming from Vinnicombe Street, is the very man to give a demonstration.' And he did so, right there, and I assisted with an oral description. This, of course was as bizarre as you could get, as it was done on the top of Ben Wyvis as we few mountaineers had stopped for a bit of a break.

'The ned must stand with feet at a 90 degree angle and slightly apart, very like a military stance, but ever-so-slightly slouched. Thereafter, the legs should remain motionless, except for occasionally giving a little kick, more like a flick, and to no apparent purpose. Maybe it's a wee reminder to anyone looking that it is there.

'The trunk is slightly bent forward and the hands are in the pockets except when holding the "Barlinnie Special"'.

'This will be between thumb and index finger and when puffing it will be held in the mouth by those same fingers, but covered with the hand as if hiding the fact that anything is being smoked at all. The smoke is inhaled deeply and having completed this ritual, it is expelled through the side of the mouth as if it resents coming out at all. Accomplished neds may also blow smoke rings. This in itself is an advanced and complicated social ritual.

'In between puffs the fag is held by the same fingers, still cupped in the hand but behind the back in secret until it is again required for inhalation.

'Besides this necessary movement of the limbs and mouth, motion is all at the level of the shoulders and above. The nearest you can get to it is in the ritual movement of the pigeon or "doo" in Glasgow.

The head comes forward as in the cooing motion and as it does, the chin gives both slight sideways and upwards movement, the muscles in the scrawny neck visibly stretching. The practised can also add in an ever so slight shoulders movement, which starts at one side and ends at the other.

'As on an automatic schedule, there is then a downward look at the shoes, immaculately polished. He is checking that this polish is perfect and that the seam in the strides is also knife-edged.

'From time to time he will also bring two hands up to pull the collar of the jacket straight and may even look around to check himself in a nearby pub or betting shop window, from which he may be taking a break if he is not barred. This sequence, all being complete will begin again until the ned decides that he should move on and demonstrate his neddishness at some other street corner or go home to tap money for fags from his mother.'

All of this being explained, one of the perplexed mountaineers asked, 'Okay, but what is a ned?...'

Of course the ned is perennial and the brothel creepers of the 50s gave way to winkle pickers of the '60s. Doc Martins were sported in the '70s and we moved on to trainers and shell suits in the '80s. I see that we are now back with winkle pickers. I hope they bring back brothel creepers. Crêpe soles are good for my flat feet, which my chiropodist says are like pancakes. Cheeky bastard.

Technical Note #1: A Barlinnie special is a needle-thin cigarette of a very small amount of tobacco rolled up in thin paper. Bronco or San Izal could be used when official Rizla cigarette papers were not available.

She had a face like a skelped arse.

Technical Note #2: Ned Kelly was of course a very well known Australian specimen of ned.

What dae ye mean?
Whit dae ye mean what dae ah mean?
Ye know whit ah mean!
Whit <u>dae</u> ye mean?
Dae ye mean whit ah think ye mean?
Whit dae ye mean?

Were you on the lorry when you fell aff?

Why are you looking so pale? A bucket fell on ma heid!

# Halicon Days

One of the problems about being well-read like what I am is that like learning a foreign language you often don't know how things are pronounced unless you hear the word. So smartarses like me who want to impress others with their learning should really make sure that they know the words if they are to avoid embarrassment.

I refer your honour to the incident in the Beer Bar that has long remained with me and in latter days has also given much mirth to my family.

The Beer Bar, as any Glasgow student will know, is the Glasgow University bar in the students union. That is the bar, once said to be the longest in Great Britain, in which students of the early 1970s entertained themselves with such community singing as 'Rapella', which started 'Ra pela moon was shining above the green mountain...'

Anyway, there we were, students and pretend students having a discussion about politics as much as we could with our vast experience of life. I said something along the lines of, 'That's what it was like in the "halicon" days.' I knew that it was spelled "Halcyon" but it came out as "Halicon".

There was a silence. 'Whit?'

'The "halicon" days' I said to a crescendo of laughs, scoffs and other slings and arrows. Bastards! That put me back as much as the time I stood in front of a hundred people at the St Patrick Scout Show and thanked the mothers of the Scouts for having them and hoped that they would have many more. If slinking was the word, I well and truly slunk.

'Dae ye want a cake or a meringue?'
'Naw, yir quite right. Ah wid like a cake!'

# Ah'll See You When You're Better Dressed

It is with great delight, if not relief, that I can tell you that I escaped being a hippy. I therefore do not have photographs of me sporting a kaftan, cowbells and wearing flowers in my hair. Perhaps this is because I started an apprenticeship and became a weekend folksinger, requiring the Aran sweater (I refer you m'lud to the evidence in 'The Folk Singers').

I feel a bit sorry for the twentyagers now. When I was one in the '70s photography was still in its infancy and I was about the only person I knew who took photographs. It was normally only practised by street photographers, who plied their trade mainly in seaside towns. In fact, here I am (bottom right) in Helensburgh, caught by such a person...

Are those Scholl sandals you ask? Well, yes and they were quite popular before flip-flops. Note the girls in the background also wearing bellbottoms.

Now, however, we have cameras everywhere and young people's dress sense is likely to be recorded for their later embarrassment. In twenty-thirty years' time, parents are likely to be asked indelicate questions, such as:

'Eh dad, why have you got a bolt in your nose/eye/ear/lip?'

'Mum, whits that poking oot o yer belly button?'

'What is a 'muffin top?'

'Da – why are yer troosers at yer ankles?'

'Whit is a shell suit anyway?'

We finished the '60s glad to get out of uniform: school, Scouts, Boys Brigade, altar boy. We then immediately adopted our own, which set the standard for both recycling and expression. For example, you see me (top right) resplendent in an ensemble of recycled Scout shirt and a pair of well-washed jeans, into which were inserted a blue coloured dart with a broad cuff at the bottom. I can assure you that this was typical early '70s and was both avant-garde and de rigueur. As were the Chukka boots!

Bearing in mind that we were the baby boomers and were not used to buying new clothes on a regular basis, we wore shoes till our eyes watered, but we were generally thin and our jeans lasted for ages. While we didn't

Quel Poseur.

The author in the '70s.

Chukka boots.

have charity shops, we scoured the Barras and the Army & Navy Stores for cool gear. One of my best buys in a shop in the Saltmarket was an ex Dutch Air Force gabardine pilot's coat, which lasted forever until it was stolen by a Dutch Air Force pilot.

I am six foot three but we still wore platform shoes. I had a pair of size-twelve chunky blue suede shoes that I loved, and I also remember a fine pair of 'wet-look' boots. Yes – Well how is that more stupid than what you have now?

So I was so cool going to day-release classes in platform shoes, loon pants, blue PVC jacket and college scarf. And don't forget the skinny rib tank top.

Actually, I had to rethink this ensemble when I heard the Peter, Paul and Mary song:

> I'm in love with a big blue frog
> A big blue frog loves me
> I'm in love with a big blue frog
> He wears glasses and he's 6 feet 3

Spooky or what as I am 6 foot 3.

**Grants are certainly going to be here for the next 800 years**

Grants may not have been in Glasgow for all its 800 years, but they certainly hope to be here for the next 800.

Being Scotlands national furnishers, Grants know everything about furnishing. They know what Scots need in the home and what they want — and they produce the merchandise at the correct price.

That's the thinking that's got them to the top and will keep them there for the next 800 years.

**GRANTS**

SCOTLANDS NATIONAL FURNISHERS
Jamaica Street/Argyle Street Glasgow

I love the positive thinking.

By the '80s most of the baby boomers had become relatively conservative and I am glad that I was beyond wearing Doc Martins and, with tartan scarves attached to my wrists, going to see the Bay City Rollers.

I am also very glad to have seen but not taken part in the punk rock era of the Sex Pistols and Johnny Rotten. No safety pins to hold me together. I do remember one particular incident in the unemployment benefit office in which I worked. A girl with a black punk outfit held together with safety pins and chains came into my office to 'sign on'. She came up to the counter and plonked down an old-fashioned steam kettle. With a straight face from out of the kettle she took out a purse and extracted her UB40 signing card. Waow!

This reminds me of a very difficult but hilarious incident in the same office. I was walking by the enquiries section, where there was a wall separating enquiries from the main office. Two staff were doubled over trying to keep from laughing.

'Michael – can you deal with this guy? We just can't.'

I peeked round the wall and quickly pulled my head back. 'Right,' I said. 'Leave it to me'. With very little confidence, I might add, as I could hardly stop myself laughing. I went round the corner to deal with the

cove that had arrived. He was about forty years of age, very soberly dressed in coat and scarf and not at all unusual, except for the biggest Mexican sombrero that you have ever seen. In Bridgeton? Someone was surely extracting the urine?

So with all the gravity and credibility that I could muster I approached the chap realising that in terms of equality, he must really be dealt with like anyone else.

'Buenos dias Señor. Can I help you?'

It was a great relief to me that he had a straightforward enquiry and a sense of humour. I dealt with this hombre easily and it was handy that I knew a wee bit of Spanish. That's a Glasgow education for youse.

I once also knew two Spanish firemen called Hose A and Hose B.

It also reminded me of the very first Italian restaurant that I went into in Glasgow. I heard that the chef actually came from Madrid. I was surprised, as I didn't really expect the Spanish in the kitchen. But then again, no one expects the Spanish in the kitchen. (I did warn you. This is a book for baby boomers).

Where's it gone?

Where was I? I can get carried away. Oh yes. At this time I thought myself somewhat sartorially elegant. For instance with my blue suede platform shoes, tight fitting midnight blue Cecil Gee velvet strides and a see-through pale blue polka-dot shirt, I was awfae swanky.

I sported this when we had a party in the flat shared with friends – two orphan brothers – in Langside. Sadly my pal Michael died quite some time ago but I believe that Paul is still an orphan. Anyway, the flat was small and crowded, and like Glaswegians often do when floor space is running out and they are pished, they take to the wardrobe. So there were chum and I at either end of a huge wardrobe, debating important issues, when McB spotted us and took umbrage.

He realised that his brother Michael's tin flute was being crushed. A fair amount of umbrage being taken, he proceeded to attempt to haul me from out the wardrobe while throwing fists at both of us. In the meantime two kind chaps were trying to interfere with this manly bonding and stop it. In the ensuing melee and surrounded by wailing women, my fine shirt that I got in a sale was ripped completely and forever off my torso. This event was to encourage me to stay out of wardrobes and to invest in proper shirts. 'Ye buy cheap, ye buy dear!'

As I said, we were thrifty and clothes were expensive. This being the days before TK Maxx and Primark. We were required to shop in the new boutiques like Cecil Gee and Mr Bojangles. Now, to my disadvantage, I was hirsute about the face (I had a beard). This was not simply because I was trendy or could not afford the blades. I have very sensitive skin about the neck and would get very sore when I shaved. I took to the beard to solve this, only occasionally shaving and therefore frightening the horses and my children when they came along.

The problem was, and still is, that the hair around my dewlaps is very wiry and the very first thing that would go would be the collar of my shirts. Now, besides the see-through shirt, now gone, I had quite a large wardrobe of shirts with collars in various states of disrepair. I happened to mention this to some cove and was advised that there was a brilliant tailor's in Bath Street that would renew collars on shirts for about three for a pound, or whatever it might have been at that stage.

So with great enthusiasm I took a pile of my shirts to this tailor and was told that that would be fine. All they had to take was a piece of the bottom of the shirt tail.

I duly returned to the shop to collect my shirts, which all had nice new collars and were neatly ironed and folded. It was only when I got them home that I realised that true enough, they had taken a bit out of the arse end to fix the collars but had replaced the missing bits with material from some other shirts, some of these being hideous pinstriped efforts or shades of magnolia or heliotrope. One or two that had longer tails were

# Lewis's

# The biggest department store in Scotland

**LEWIS'S LTD. ARGYLE ST. GLASGOW G28 AR**

Not any more it's not! Gone as well.

not so bad but with the shorter tails my arse was truly hinging oot o ma troosers.

The only time that I could wear the shirts was when I had on a jacket, and therefore rarely in the summer. One time I forgot and it was almost akin to the mirth occasioned by 'halicon days'. The shirts went into the bin. Bastards!

Is that your Ayrshire bacon?
Naw, I'm just warming ma hands

While we are on it, what gave them the name of calling the shop in Renfrew Street 'West End Misfits'? That's shocking.

Actually, before I leave this saga of clothes and shopping, I must tell you about an encounter I was told about in a tailor's shop in the '70s. That was before the advent of credit cards and cheap and easy credit. A friend had ordered an expensive suit but couldn't afford to pay for it outright. He was offered credit but you needed to have a guarantor, which is someone who would guarantee that you would pay or they would have to! Anyway, they couldn't think who they could get at short notice to sign, as they needed the suit for a wedding.

At this point a guy dressed in a cowboy suit and wearing a mask approached. He said, 'Sir, I couldn't help but overhear your problem. I would be very happy to help you out here.' At this point he took the form and signed his name. The shop assistant didn't appear to be perturbed and duly packaged the suit as the cowboy strode out of the shop. My friend could see him getting on to a horse and riding away.

My friend said to the shop assistant, 'Who was that masked man anyway?'

'Why, sir, don't you know?' said the shop assistant. 'That was the Loan Arranger'.

# Willie Logan, Me and the Kingston Bridge

I remember when I had been at primary school; part of the building had been a 'junior secondary school'. This was at a time when the 'qualy', a.k.a. the Qualifying Examination, taken around age twelve, elevated you to the prospect of going on to senior secondary school or condemned you to the junior secondary, where your fate was sealed to live life in a boiler suit, the colour of which was dependent on the trade you managed to get into. In addition, there were 'selective schools' like the one that I got into, St Mungo's Academy, run by the Marist Order. In addition, by the way, there were also Catholic private schools like St Aloysius and Notre Dame.

Anyway, I passed the qualy and was accepted into St Mungo's Academy 'The Mungo'. So I was headed for greater things than the shipyards. Meanwhile the boys in the secret part of my old school went on to make coal shovels, twisted metal pokers, toast racks and other domestic goods. But I was marked down to better things than an artisan.

Of course, in those days we had little understanding of the move towards the comprehensive school system in which I had no part. The irony was that the selective school that I was destined for was in the centre of the city while there was a perfectly good senior secondary, St Thomas Aquinas, within cycling distance.

For me, the 'qualy' was wrong and while we can't go back and change things I would have been far better off making pokers in my secondary school years. Because after a few futile years with little benefit and some costs to me I was branded a failure and I do remember the parting words of a respected teacher: 'Meighan, you'll never amount to anything.' It is true that we are only limited by our teachers.

I suppose the desire in me to write was actually very strong. There was to be more of that later, but in the meantime the bottom line was that I had very few qualifications to allow me any further sloth at the ratepayer's expense, so I had to make my way to the Labour Exchange to see what I could do about my life.

I built it!

Well, the Youth Employment Service sent me on many a fruitless mission to far away places like Weirs of Cathcart, a non-descript laboratory in Bath Street, and other sundry non-starters. I know why I didn't get the job in Colville's in Cambuslang. I got on the wrong bus and as I tried to find my way over some waste ground, knowing I was already late, a seagull shat on my jacket. I had a hell of a job trying to clean it off with some grass. I wouldn't have given me the job.

In the meantime I was making a bit of an effort myself. I don't remember why or how I came to approach the bluff tunnel master at Anderston Cross, but it was a complete surprise to me that he said, 'Start tomorrow and we'll

**The Colville Group of Companies Iron and Steel Manufacturers**

Developments within the Group have increased our production capacity and with this our need for technically and scientifically trained men. To the school leaver we offer the opportunity of practical training allied to a suitable course of study at a College of Further

Education to prepare him for a satisfying and interesting career.

*For full details write to :-*
The Group Education & Training Officer, Colvilles Ltd , Park House, Park Street. Motherwell.

**COLVILLES LIMITED**

They didn't think I was satisfying and interesting.

see.' He was a rough Irishman pulling a gammie leg, but I was later to find out that he had a fierce reputation, he treated you fairly.

Although I had a good idea of what was happening as far as the clearances were concerned, I had very little idea of how they were going to build the motorway and the Kingston Bridge. I was soon to find out.

For a couple of years we had seen the preparations for the Kingston Bridge. This included the removal of the old cemetery in North Street and the church in Heddle Place and a swathe of tenements up through Charing Cross and down to the river. It was one big playground and I suppose it was because I knew the area and was still hanging around that I looked for a job there. Little did I know that I was forging a connection with my future wife's hometown, Dingwall.

The job I got was on the construction of the main sewer under the motorway, which would take surface water to the Clyde. It was a joint contract between Logan and Marples Ridgway. I was to learn on the job that Willie Logan was the main contractor to the North of Scotland Hydro-Electric Board and had had a major role in the building of the hydroelectric dams with which I was to become so familiar in future years.

The hydroelectric scheme came out of the need to provide electric power in the '60s and was driven through relentlessly against the major resistance

# Logan

# THE SIGN THAT THINGS ARE HAPPENING

All over Scotland, wherever there is construction work in progress, you will see the name LOGAN. New bridges, motorways, building work of every kind—Logan Construction is playing a big part in shaping the Scotland of tomorrow. So remember, next time you see the name LOGAN, it's a sign that things really ARE happening.

# Logan | MUIR·OF·ORD & GLASGOW

Horse for Logan!

of landowners by Tom Johnstone, the first Labour Secretary of State for Scotland after the Second World War. His vision was to produce one of the greatest engineering feats of the twentieth century as well as make household names of such entrepreneurs as Willie Logan.

During my campaign for Parliament in 2000, which stretched over a year from when I was selected, I was struck by the ignorance and sometimes resentment that people had about the Labour Party's achievements in the Highlands and Islands. Not only was there little knowledge of Tom Johnstone but few people were aware that the Labour Government of 1945 had given them the North of Scotland Hydroelectric Board. It had also revitalised the Forestry Commission and had started the Highlands and Islands Development Board, all of which were to have enormous impact on the development of the Highlands and Islands.

The Building of the hydro dams was to produce personalities and heroes. Among these was Willie Logan, who was instrumental in the story of the dams as well as starting an independent airline company, Loganair.

When I worked for him on the Kingston Bridge we never met, but as far as I remember most people that I worked with had a soft spot for Willie, who was seen as a fair man and something of a folk hero. They had an expression for him then showing their commitment to him: 'Horse on for Logan.' These included the hard-working and hard-drinking Irishmen. The Irish navvies were hard men and many's the time I would see them turn up

Loganair Ltd.
First Scheduled Flight
Glasgow – Islay
1st April 1977

Carried in BN 2A Mk III Trislander G-BDOM
Glasgow - Islay (Port Ellen)
Flight No: LC 2661    Flight Time: 39 min.
Capt. Henley   F/O Crisp

'Ah wis a cowboy builder.'

to work in a suit, step out of a taxi, get into cement-encrusted jeans and go down below to the compressed air tunnel. There they would stay for eight hours at a time, digging sand and stopping very briefly to eat sandwiches and scoop tea out of a large enamel pail. It was one of my jobs to bring it to them.

These were the same navvies who built the dams and who accepted the inherent dangers in the business. They talked about the 'bone rot' or asked, 'Now how much did so and so get for that arm/leg there?'

Now Willie and his wife lived in Dingwall in a relatively modest house on Kinnairdie Brae. Jill, my wife, also from Dingwall, tells me that every year he and his wife would give a Halloween party complete with dooking for apples. She told me that he was a very pleasant man. Unfortunately he was killed tragically in the crash of an small aeroplane on his return from a meeting in England. Ironically it was not a Loganair plane as none were available.

Loganair has played a major part in the development of the dams as well as of the Highlands and Islands.

Loganair is now a franchise of Flybe, although it has a nominal Loganair sign on the planes. I have a soft spot for the planes as they have given me many an interesting experience. It is also a great source of pride to me that while we were moved from Anderston to make way for the Kingston Bridge I am able to say that I helped to build it.

The Hanging Gardens of Kingston.

# 'The Pye'

In 1963 Harold Wilson, the Labour Government Prime Minister, made a comment on the scientific revolution, now referred to as 'the white heat of technology' speech. We did have a time of unprecedented growth in technology and by the early 1970s this was in full flow. Just remember *Tomorrow's World* with Raymond Baxter. I think I can say that I am quite proud of having been a part of that. Following my short time on the Kingston Bridge I got 'a start' as an apprentice electronics technician with Pye Telecommunications in Airdrie, with the first year spent at a training centre in Shawheed, Coatbridge.

It was amazing to me. Although I had been introduced to engineering in my short time as a tuneller, the move into electronics was quite awesome, not in the least because 95 per cent of the shop-floor workers were women and I had been to an all boys Catholic school where the only girl was in the school office and where reasons for visiting the office were many and spurious. I can say the shock to my system was complete.

I was at Pye for two years, getting used to the routine of manufacturing and the banter on the shop floor. The early mornings were still a challenge and I had my father to thank for getting me up at 5.30 a.m. I was getting used to it. The factory atmosphere was clean and most folk were friendly and you had an idea that you were working on something worthwhile.

Ours was one of the factories for producing the new telephone GPO 746, among the very first to be produced since the old black Bakelite ones in the 1960s. We produced parts for the Pye Cambridge radiotelephone used in police vehicles and taxis and we made mine detectors and a variety of other equipment for the General Post Office (GPO).

While the travel was difficult, it was made up for by the relaxed atmosphere and there really were 'three nights and a Sunday' (double time) as Matt McGinn had it. There was a comfortable, clean canteen where I think the managers ate with workers and the food was subsidised. I could have had a career there and sometimes I think that if I had stayed I would have stayed a long time, at least till they closed the factory down.

# AIRDRIE ELECTRONICS LIMITED

ONE OF THE PYE GROUP OF COMPANIES

**Contractors to Defence Department and the G.P.O.**

The GPO 746 (1971). Very modern.

During this time we were taken on various site visits. I remember two of these particularly. I had been in primary school in St Pat's in Bishop Street in Anderston and we were right next to Dial House, the GPO Telephone Exchange. We were taken there once for a visit to see all the cheeky telephonists on their metal swivel chairs plugging in the wires to big boards in front of them. There were columns of connections that continually clicked, purred and buzzed.

If I hadn't been there then my visit to the very first digital exchange, somewhere on the Clyde Coast, would not have meant very much. For that small exchange was almost silent and only manned by a couple of people. The workings were all contained in cabinets, which were cream-coloured and only gave out a low hum. It was explained to us that this was to be the future of communications and bearing in mind that the only other reference was Dan Dare in the *Eagle*, it was very difficult to take in. I since found out that we have always been at the forefront of developments in communications. Apparently Glasgow had the first telephone exchange in Great Britain, this being opened by D & G Graham in 1879 and called The Glasgow Medical Telephone Exchange.

The other experience was being taken to the Institution of Electrical Engineers Faraday Lecture, named after the scientist Michael Faraday. I remember this one being held in the Usher Hall in Edinburgh and while we were farting about up the back of the gods, I still remember being introduced to the integrated circuit and the silicon chip. Bearing in mind that we were still working with valves and lots of metal, this development seemed so far away in the future, and I had no idea that I was becoming part of it.

If I thought that Pye was a fine example of the future of Scottish manufacturing I was in for a rude awakening. We were still at day release courses at Coatbridge Tech, which was as dull as it was antiquated compared to the new Engineering Industry Training Board Centre at Shawheed, LETA. Can you believe that in 1970 we were still expected to sit in those old double desks with the holes for inkwells?

While I served my apprenticeship and became a 'journeyman' instrument maker my heart wasn't in the job, mainly because I had made a transfer to Barr & Stroud at Anniesland. While there was nothing particularly wrong with the job, I found that I had moved from a production factory with all of the laughs of working on the lines to a secret research facility in which there were no laughs whatsoever.

While 'The Pye' was modern and forward-looking, Barr & Stroud was very Victorian in its outlook and treatment of people and I felt quite isolated. Therefore I decided that I would improve my qualifications and 'get on'. This did involve me going back to FE College and then going on to Aberdeen University before moving to England.

I have decided to dedicate this chapter to Nancy and John Weir of Airdrie, whom I bumped into very recently when they had decided to spend a weekend in Dingwall. I forgot to ask them why on Earth they had decided to do this, but afterwards realised that the Airdrieonians had travelled to Victoria Park to play Ross County. They were possibly in that contingent.

Anyway, I happened to be walking along a road in Dingwall towards the house of a friend when a car drew up and a very pleasant person asked me if I knew the way to Tulloch Castle. I certainly did and vouchsafed my opinion that they were heading in the wrong direction.

I had pointed them in that direction when the lady asked me if it was a real castle. I tried not to laugh, but in the Highlands we have more castles than you can shake a stick at. I had forgotten that people do actually come to the Highlands for the romance of the place.

We got talking while we held up the traffic into and out of Munro's sawmill and having realised that these people were not from the area I suggested that they might be from the Glasgow area. Not there, they said, but from Lanarkshire, from a place called Airdrie.

Small world, I thought. 'I served my time there.' They were truly amazed, as Nancy and others of her acquaintance had worked there, probably when I was there and even on the same lines. Certainly I often repaired the cableforms that she mentioned.

They asked me if Tulloch Castle had any ghosts. I decided not to scare them and I hope that they did not indeed meet 'The Green Lady'. Nice to have met you, Nancy and John. Give my regards to Airdrie.

# Larchgrove

For those from Glasgow, and particularly the east side, Larchgrove should need no introduction, although when I saw the job advertised I only vaguely knew of its existence, although it was directly opposite my auntie's house in Easterhouse, but on the other side of the Edinburgh Road.

I had completed my additional 'Highers' at Langside College and was again at a loose end while waiting to get into university. I also needed income. I saw the job for supervisors at Larchgrove Assessment Centre and duly applied, as they did not appear to be asking for many qualifications – for which I was well qualified.

Anyway, I got the job and it was only when I got a start that I found out that there had just been an enquiry into the poor treatment of the inmates and several staff had got the heave-ho, including the big banana. This did not put me at my ease to begin with, particularly as a very nice chap that started with me got the big elbow within a few days of starting because he was caught taking the slipper to a child. Now he didn't get that idea out of the air.

I stayed there a few months while waiting to get into uni. There were certainly a lot of very strange people there with some very strange ideas. The youngsters were fine though.

Larchgrove was supposedly a centre where young people would be sent by the Children's Panel or juvenile courts and we would assess them and send them away with a report covering their attitudes. I shiver now to think that I may have been responsible for recommending that a young person would either be detained or given probation. I say this because I had absolutely no training in assessment techniques. The only young people I had actually come across were my fellows in school, altar boys and Scouts. I was certainly not equipped for this.

Neither was I equipped for the kind of things I saw. Now, I will not say that it was a violent place, except that the violence was often done to themselves by breaking window panes and using the glass to carve their own names into their arms or 'LOVE' and 'HATE' onto their knuckles.

In the '70s, Larchgrove was run by the Corporation of Glasgow, as were all the other services. I think this was a wonderful title, reflecting as it did the power and the importance of 'The Corporation'. Glasgow City Council simply does not have the same ring to it. (There's an allegory in there if you look for it but then maybe you would have to look up 'allegory' first and then forget what I was saying. No, just forget it.)

Where was I? Oh right. With my extensive knowledge of the culture in Glasgow gained from many visits to the galleries and parks I was very aware of the vast amount of the ratepayer's money expended on works of art, film and exhibitions. I was also aware that the Education Department spent a great deal on encouraging pupils in the arts including school visits to hear classical music. So I was surprised and embarrassed by the lack of resources available to the staff and residents at Larchgrove. While there was a valuable joinery workshop there was little else to occupy the lads besides playing shove ha'penny.

One of the reasons given for this was the lack of respect for any resources. One example was snooker. There was an attempt at improving activities by the purchase of a small snooker table but there was an insistence that the snooker cues should be bored with a series of holes down their length that would make the cue break easy if it was used as a baseball bat! That I suppose would not help if it was used to poke out an eye as with a sharp stick!

Anyway, the dilemma was solved one day when two of the bright lads picked up the snooker table, tossed it through the plate glass window and followed it into the blue yonder. They should go far. Probably Barlinnie. And they used to disappear with regularity and I have to say a 'runner' was looked on with some anticipation by the inmates as it gave some excitement to an otherwise dull existence filled with such exotic activities as shove ha'penny and basket weaving. (Honestly!)

The staff were responsible for ensuring the captivity or sedation of the young people and it was seen as a stain on their character if they lost a lad under their watch, irrespective of the fact that they would be back sooner or later. I had a slight problem in this respect, in that the food for both adults and children was excellent. There were full meals at all times and boxes of sandwiches and cocoa at suppertime. I put on a great deal of weight and I also smoked. So therefore a 'Young Tong' of fourteen and having the leanness of the streets would easily have beaten me over the railings and into the warren of houses that was Barlanark in those days. Strangely enough, looking around at the largeness of today's youth, I might even have a chance of catching them now. Maybe not.

One thing that did break the monotony was the Sunday night film that was shown on the creaking old 35 mm projector. Now bearing in mind that this was an 'Assessment Centre', inmates would theoretically be based

there only for a short time. In reality this was not the case. The extreme cases would be 'disposed of' quite quickly to Polmont or Longrigend, the Young Offenders Institutions. The mild cases would be sent home quickly. But in between, there were young lads who stayed for just too long and learned a bit too much about a life of crime. They also learned more about creativity than their peers in the secondary schools.

Anyway, we saw films that were pretty old by any standards. I remember such gems as *El Dorado* with John Wayne and Robert Mitchum. But what I remember most was the time we were sent *Trip to Mars*, Volume 7. Now even I had forgotten the early TV programmes in which spaceships were made out of tinfoil and washing boards and were sent into space with the power of Standard Fireworks. ('Light up the sky with Standard Fireworks' sung by choirboys. You must remember!)

It was clearly an early incarnation of Flash Gordon in black and white, even at a time when the children on the outside were getting used to James Bond in such epics as *Thunderball*. *Trip to Mars*, Volume 7 came as a bit of a shock and a mystery. Some were simply enthralled at the badness of it. Some of them quite rightly thought that they were being patronised. And some of them just stared into space as usual.

As we had been given Volume 7 when Flash had just been seized by the alien invader with the dustbin lid hat we wondered if next week we would be sent Volume 8 so we could see what had happened. Sunday came and we opened the brown film box. There it was: Trip to Mars Volume 7. Again! Someone was taking the piss. I have to tell you that maintaining control that night was rather difficult. Maybe it should have said '(R)' on the box and we would have ignored it.

At the weekends, one of our jobs, in the absence of a nurse, was delousing, one of my least favourite jobs. Normally we would receive young rascals from other institutions but on some occasions, at the weekends, we were sometimes called upon to receive youngsters picked up by the police from the streets and who had not been sent home with a warning. This was usually for the more serious crimes like dropping litter or playing kick the can outside a councillor's door. 'Stoat the ba' was a hitherto unknown term to me – for the sad propensity of some young people to interfere with other young people in an inappropriate fashion. (Are you with me here?)

Anyway the offenders would appear at the door flanked by officers of the law, who, interestingly enough, were often very deferential to us custodians of the youth of today. We would receive the lads, who were often in a dishevelled and hungry state, usher them into a shower, and then ask them to stand naked on a towel. We would pour liberal amounts of white nit powder on to their heads and this would cascade down. When these new or recidivistic lads were de-nitted they would be well fed and

introduced to their fellows in the common rooms, where their powdered heads would be greeted with hoots and jeers of derision. I am sure that Charles Dickens must have visited Larchgrove to get some of his ideas.

On one occasion I was very suspicious of the amount of Polo Mints that were being consumed, even to the extent that parents and chums would be taking in whole boxes of that famous confectionery. Now the wisest of you will be following me at this point. This was at a time in which smoking was not allowed in the building, except at very regular times and by very regulated amounts. We cared about their health.

Anyway, as chewing gum would normally be a more likely substitute I wondered about the Polo mints and I earned myself a reputation as a bit of a spoilsport by opening one of the packets to discover a Player's No. 10 neatly inserted down the middle of the holes. Ten packets of Polos equalled a packet of ten fags. Good bartering money. It was the stuff of *The Great Escape*. Polo mints were banned. As a present, some bastard of a young pickpocket lifted a newly opened packet of fags from my jacket pocket. You couldn't trust the youth of today then either.

Of course, the Young Team were as daft then as they are now. You only had to notice a distinct silence to know that something was afoot, such as an escape back to the Glasgow badlands. I sometimes thought that this was a bit of bravado as they were being looked after quite well. So well

You're a big diddie Meighan, it's no that way.

done to the young lad who appeared back at the front door to ring the bell after having been pursued through the back courts by me for two hours. Personally I thought solitary confinement was a bit harsh.

As soon as you heard the whispered 'edge it' you knew that some contraband was being hidden or that some idiot was tattooing himself. There were the lockdowns too, when a chisel went missing from the wood workshop or a knife from the canteen (such things always being counted in or out). Basically the building was locked down and searched, with no movement and no food until the said object was mysteriously found, maybe stuffed down a toilet.

Talking of which reminds me of big Rolf, who was both a gentleman and an artist. He had a slight speech impediment, which we called in those days a stutter. On a Sunday afternoon when we were preparing for the long awaited *Trip to Mars*, Volume 7, we would line up our respective groups in the corridor ready to enter the common room. Rolf had just said something to his group which was then repeated by a very silly bad boy: 'qwwwwwwiet thththethere...' Of course, I could easily see the perp and I simply pointed him out with my finger to Rolf.

Rolf then quietly retaliated by saying to the young impersonator: 'Yyyyyou ssssonny, cnnnnn missss the fillmmm and cccclean out the shshshshiter.'

Nice to have met you Rolf.

I can't remember any of the lads except for one. He was about twelve, I think. It was about my second week and I was no longer a novice, being put completely in charge of three dormitories of the younger lads ensuring that they were showered, changed and bedded down for the night. As this was going on I was required to take possession of Ned (let's call him that), whose incarceration was explained to me by the policeman who was glad to get rid of him.

That Saturday he had, along with several as-yet uncaught offenders, taken without authority through shoplifting several dozen items of electrical goods. He then, again without the owner's consent, had taken possession of a very new Austin Mini. Upon being pursued by the police, he had parked it very neatly across the pavement and between a lamppost and Rogano's restaurant at the corner of Kent Road and North Street, next to the Mitchell Library (Yes – they did have one there). By the time he had arrived with me he was knackered. Trying to keep my eyes on about two dozen other similar scallywags, I helped him out of his rancid jeans and t-shirt and into the shower. The young lad promptly fell asleep in the heat of the shower from where I had to pluck him, slot him into his PJs and insert him into the nearest available bed where he slept though the settling down of the rest of the dorm.

I learned a lot at Larchgrove and very nearly went back to social work. I learned a lot about how not to deal with young people and I also found out

how good and resourceful they can actually be when called upon. Through some very big wars, these are the very young people that Glasgow called upon to defend life and liberty. I always thought that they deserved more than the dismal portrayal in *No Mean City*, incarceration in Larchgrove and *Trip to Mars*, Volume 7.

And you know something that has just occurred to me? Larchgrove was non-denominational, in that Catholics were not segregated from others. I do not remember any instance of religious bigotry at all. Isn't that strange? Maybe it's my memory.

The above, by the way, reminds me of the motto of Rogano's restaurant. I think it was 'Carpe Diem' ('fish of the day' or maybe it was 'seize the fish'?). We learned Latin at my school as well as Spanish.

Apparently with the move towards 'fusion' foods you can now get a fish curry called a Rogano josh. Well if they don't do it they should. Although as you know, I won't be eating it because 'see me, see fish...'

# The Brick

What happened to Glasgow while I was away? Or had it always been that way? Where had the dignity of work gone?

It concerned an ordinary brick.

My confession is that I have a fascination for bricks and I would collect them as others might collect stamps or paintings. Well, maybe not paintings. Totally weird I know, but bricks are pieces of history through which you can map the development of industrial Scotland.

The making of the common building brick was closely associated with coal mining and brickwork kilns were often found beside collieries. As with mines, there are few brickworks left. My own memories are playing in and around Dodds brickworks on the Royston Road. There I would watch the clay being manually forced into moulds, turned out and placed on flat barrows to be wheeled into kilns where they would be fired for several days until ready.

Like stamps, bricks are identifiable. While they have logically moved towards a common size, they kept their individuality through the imprinting of the brickwork name in the centre of the brick. Besides Garngad, my collection included Blantyre, Walkinshaw & Garscube, Hurlett, and Nitshill.

Sadly my collection is now limited to eight bricks holding up a shelf of plants on our balcony. The rest of my collection is now left behind holding up water butts and barbecues or in the paths of former Meighan residences.

Anyway, I had been visiting offices in the remnants of one of the heavy engineering sites, common in Glasgow when I had served my time. What had been huge workshops were now vast, empty rubble-strewn brokies. The factory offices were now occupied by a variety of small companies, one of which I was visiting.

As I got out of my car in the car park, which seemed to be made of rubble, I happened to spot a complete brick on the ground, and one thar was not in my collection. I picked it up and put it into the boot of my car.

I concluded my legitimate business, whatever it was, and headed out to my car, to be followed by what looked like a security guard dressed like an American Highway Patrolman.

'Hello,' I said.

'My boss would like to know what you put in your boot,' He said, without preamble.

Well, you know it is very difficult to explain an obsession with bricks to people who don't understand. I just said with a red face, 'A brick,' opening the boot to show him. He looked at me as if I was taking the piss and clearly decided not as he hurried back into his important office to look after the important things he had to keep secure.

However, as I was heading for the gate, he hurried back out and came up to me in the car. I had the feeling that I should just get off my mark, but I stopped and wound down the window. I looked at him.

He was clearly very embarrassed. 'My boss says that if you want to take a brick you should ask'.

Barclay Curle's shipyard.

'I am very sorry for you.' I said. He turned back and I drove on.

Once upon a time in that factory there would be time-served journeymen whose work had dignity. I thought that it wasn't just the factory that had been knocked down.

# Erchie

I am going to call him Erchie, and God bless you Erchie.

My cousin has a caravan in a park on the Rosneath Peninsula. To get to it from Glasgow you get a ferry from Helensburgh just as the Glasgow gentry would have done a century ago, that is unless you go on your yacht as they might have done. They were getting away to their mansions, away from the smell, the smoke and the fog of the city.

As I waited on the ferry on a quiet weekday off-season there were two fishermen patiently passing their retirement at the edge of the broad Helensburgh pier, as I did as a boy with a line many, many years ago on the same pier.

I was at a low ebb and I kept my head down so as not to catch the attention of the gregarious newcomer with the broad Glasgow accent who engaged the fishermen in loud conversation. They were pleasant enough to the small gentleman in jeans, sweater and backpack as they told him that no, they had not caught anything. 'There's plenty mer fish in the sea,' he quoted and as they laughed with him, I still kept my head down.

The ferry came and went and I had a very nice weekend in the said caravan. I returned to Helensburgh and spent some time looking round that sad town centre before I caught the Blue Train home.

I decided that I would get off at Charing Cross and go into the Mitchell Library for a while. I did so and on leaving I thought that I would walk into the city centre. I walked down North Street and as I got to St Vincent Street I stopped to wait for the green man before crossing. There on my left was the Helensburgh pier gentleman. I was so astonished that I said 'Are you following me?'

'Are you following me?' he replied, not with defiance but maybe a touch of fear.

'You were on Helensburgh pier on Friday and here you are now.'

'I was just out for a wee while doon the water,' he replied. I mellowed as I then recognised in him the man who for years in times of unemployment had gotten away from bothering their wives by going doon the water. It

Towards Rosneath from The *Waverley*.

Two to Rhu!

also got them out of the way of drink when they had no money and when they were unemployed. My father had told me about it as he had done the very same thing. More recently the famous Tom Weir in Weir's Way had said the very same thing. Nowadays we call it 'rambling'.

Who was I to be suspicious, as I was doing the very same thing myself?

'You don't know where there's a Westminster Bank, do you?' he asked.

I said that I thought there was one down St Vincent Street and I would walk with him as I was going into town. What started off as a suspicious meeting turned into me hearing his story about being out of work and needing to get out of the city. He had indeed gone to Helensburgh and with no money left, slept rough in Cardross. We had a great wee talk as we walked together down St Vincent Street. He wasn't looking for a handout but as I left him I gave him a few bob, which he gratefully received, as a friend would. He was a nice man and he left looking very pleased. I felt a bit humbled.

That weekend made me realise how beautiful the Clyde Coast is and how close it is and how precious it is to the people of the City of Glasgow. A recent trip on the wonderful *Waverley* and to Mackintosh's Hill House in Edinburgh shows just how well we are looking after our heritage. Here's to all of the volunteers and staff who help.

# Wiglies (Works in Glasgow, Lives in Edinburgh)

For historic and personal reasons I now stay in Edinburgh and work in Glasgow. It was different in the '70s when I was doing it the other way round. In the '70s there were relatively few artisans who lived in Glasgow and made their way to the capital to work. For a while, when rediscovering my building skills, I did so and made my way on the old diesel train clutching my Willie Logan Marples Ridgeway hard hat, for fear of getting it 'knocked' on site, but really I felt quite macho with it.

While waiting for some university to open its doors to me I had got a job with Forest Construction, then of Robertson Street, I think. I worked for them occasionally but this first one set me on a path to discover Edinburgh and the process of stone-cleaning.

Talking of the Edinburgh-to-Glasgow train, you might remember the old-fashioned trains with the high seats like settles. You can still see these if you travel on the Speyside Railway. Anyway, one late night a few years after my first trips to Edinburgh I had made the complete transition to Working and Living in Edinburgh (wallie). I had made one of my regular trips to Glasgow to meet my pals in the Vicky Bar in the Saltmarket. I was mellow, you might say, and headed for the last train home. Now the train was virtually empty because in those days, people in Glasgow had no real reason to go to Edinburgh. I could see from my seat up to the end of the carriage and there seemed to be someone doing the 'two steps forwards and three backwards' routine. But this cove seemed to be putting two ladies into distress. In such a situation I can be quite gallant and I was worried about what the chap might do next as he was swaying to the rhythm of the train and I thought he was going to take a dive right on top of them.

So, mustering all my gravitas, I approached the hombre and said, 'Just sit down pal,' which, to my utter amazement he actually did. I say that because I am just a big softie at heart. Apparently, however, I look dark and evil.

Anyway, not wanting to bother the ladies further, I turned round to head back to my seat and my heart leaped into my mouth for there, sitting on

# We've moved Glasgow and Edinburgh 15 minutes closer together

This ingenious piece of time-and-motion applies only to the train, which zooms you between Glasgow and Edinburgh in only 43-45 minutes each way.

We've put luxury carriages on this run, but by the time you've relaxed—it's time to get off, and as there's a train every half-hour you won't have much time to hang about on the platform mulling it over. So you'll have to make a few trips before you get the feel of things. But believe us—things feel good.

When you travel this fast in luxury carriages, is it worth the strain of driving and the sweat of parking?

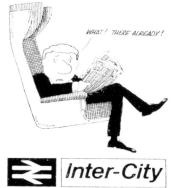

WHAT ! THERE ALREADY !

Inter-City

It's just 43 minutes between Glasgow and Edinburgh.

the 11 o'clock to Edinburgh, was my heroine Hannah Gordon along with Una McLean. Both thanked me profusely and invited me to join them. Which I did, of course, and we happily shared a few of their Benson & Hedges till I got off at Haymarket.

You might remember that Hannah Gordon appeared in the '70s with John Alderton in *My Wife Next Door* which was her first starring role. She went on to have many acting and presenting roles. These included *Upstairs Downstairs*, *Monarch of the Glen* and *Heartbeat*.

I had the great privilege of seeing her as a stage actress at His Majesty's Theatre in Aberdeen in James Barrie's *What Every Woman Knows*, in which is uttered one of the best Scottish quotes ever, 'My lady, there are few more impressive sights in the world than a Scotsman on the make.'

Una Mclean is also a fine actress. Una started her time at the Byre in St Andrews and then moved to the Citizens'. She is probably best known for her comedy roles, particularly in pantomime with the great Stanley Baxter.

Both of them studied at the Royal Scottish Academy of Music and Drama and are a credit to that institution and to Glasgow. Hullawrer ladies. Nice to have met you.

Talking of trains as we are, I am well used to the eccentricities inherent in travelling to and from Glasgow. But, with my wealth of experience I was ill-prepared for my conversation with a railway chap in Inverness when I told him that I wanted to go from Shnekie (the locals name for Inverness) to Glasgow, travel to Auld Reekie from Glasgow and then come back to Shnekie from Edinburgh.

'You'll be wanting a ticket to Shotts then,' he said.

'But I'm not going to Shotts,' I said. I don't have a particular antipathy towards that famous mining town and those familiar with my previous excursions into the industrial hinterlands of Central Scotland will know that I speak highly of the Shotts Leisure Centre.

Get oot o' here before ah punch yer ticket pal!

'That's all right' he said. 'Shotts is mid-way between Edinburgh and Glasgow.'

'That may well be', I opined. 'However, I am not travelling on that line,' knowing well that the train for Glasgow Central to Edinburgh via Shotts takes about twice the time of the Queen Street service, as it takes you on a rural excursion through North Lanarkshire, pretty as it may be in some places.

I believe that he muttered something like, 'Trust me, I'm a railway clerk.' So I purchased said ticket and it was with trepidation that

The Barras 'You want a picture pal?'
'Ye'll know me the next time'.

having travelled through Glasgow and arriving at Haymarket (not via Shotts) I was accepted through the barriers without question. To preserve the issue for posterity, I have kept the ticket.

Very recently my wife and I went to the excellent Edinburgh Food Fair, held on the Bruntsfield Links. During this we attended a cookery presentation by Nick Nairn. His food is really excellent, as is his humour.

On finishing the first plate, Scottish asparagus served up with a poached egg and shavings of Parmesan, he looked round the audience and after a pause said, 'Oh I forgot, this is Edinburgh. This is where you can clap if you want to.' Being reminded, the crowd then did so clapping fairly enthusiastically.

Just after that he happened to mention the Glasgow Barras and said, 'What's the equivalent in Edinburgh?'

Some wag from the back shouted: 'Waitrose.'

> Oh, the Barrows, oh, the Barrows, there's none in Rome or Paris.
> You've just got to go to Glasgow's Gallowgate.
> They sell tickets to the moon, return for half-a-crown.
> Five bob guarantees a first class seat.
>
> (Jim McLean)

I passed a lorry carrying portable toilets in Morningside Drive. The drivers were having a break while waiting to make a delivery (so to speak). The window was down and the driver was saying to his mate, 'I like working on this side of the city 'cos you get nice clean jobbies.' He didn't even think it was funny. Neither did his mate. I know because I stopped to listen. I'm afraid that's Edinburgh for you.

I know in Glasgow that passengers have taken to thanking the driver as they get off the bus: 'Thanks pal.' The same is true in Edinburgh except that the genteel ladies of Morningside can thank the driver and still make it sound patronising and deferential: 'Thank you driver.' One of these ladies asked a newly arrived but touchy plumber; 'When exactly will you be finished please, plumber?'

'Ah'm finished noo missus.' Quite right.

So am ah! I don't want tae miss the last bus. Thank you for your kind attention reader. That's yer time now ladies and gents please! De ye's no huv a home tae go tae?